built at the peak of construction in 1949–50. 9% of U.S. homes have television s

 yism, Julius and Ethel Rosenberg are convicted of espionage against U.S.; they a

ard Nixon, in his "Checkers speech" (a reference to a moment when his dog, Ch

nieres on TV. November 1: First successful test of the hydrogen bomb is conduc

h president over Democrat Adlai Stevenson. November 16: John Clellon Holme

Records in Memphis. He initially records Southern black musicians, but by the mid-1950s is promoting a fusion of blac

D magazine is published (the character Alfred E. Neuman is introduced 4 years later). 1953 January: Arthur Miller's Th

y. February 19: The Korean War truce is signed in Panmunjom. During two and a half years of fighting, more than 54,00

Secretary of the USSR. August 12: The USSR explodes the hydrogen bomb at the Semipalatinsk Test Site, Kazakhstar

mmad Reza Pahlavi in 1954. Ian Fleming's Casino Royale, the first James Bond book, is published. First issue of Playbo

hat public school segregation is illegal (Brown v. Board of Education of Topeka, KS). June: Senator McCarthy is censure

f Sports Illustrated is published. More than one half of U.S. homes have TVs (an estimated 26 million). Walt Disney an

s polio vaccine is introduced to the public. October: The Mickey Mouse Club and The Ed Sullivan Show premiere on TV

ct Treaty, officially named the Treaty of Friendship, Co-operation, and Mutual Assistance, is organized as military suppor

which he began in 1921. Ray Kroc begins franchising McDonald's hamburger stands. 1955 April: Bill Haley records "Roc

mar Smith, a WWII veteran and organizer of voter registration drives in the black community, is murdered in Brookhaven

lly beaten, shot, and dumped in the Tallahatchie River for allegedly whistling at a white woman. Two white men, J. W

an dies in a car crash at the age of 24. December 1: NAACP member Rosa Parks refuses to give up her seat in the whit

y (it will end on December 20, 1956, when the buses are officially desegregated following a U.S. Supreme Court ruling

w market for teen movies. 1956 March: The Southern Manifesto, which opposes integration, is signed by congressmen from

op, R&B, and country music charts. June: The Federal Aid Highway Act of 1956 authorizes construction of the interstat

l president. The Japanese American Citizens League successfully passes Proposition 13 in California, which returns land

Frutti"), Carl Perkins ("Blue Suede Shoes"), Chuck Berry ("Maybelline"), and Bo Diddley ("Bo Diddley") top the charts

ed Shuttlesworth; King is named its first president. It becomes a major force in organizing the civil rights movement and

set in the context of New York street gangs, premieres on Broadway. September 24: Though the school board had vote

n School by Governor Orval Faubus. President Eisenhower sends federal troops to Little Rock to enforce desegregation

ent abolishes poll taxes, which had been instituted in 11 southern states after Reconstruction as a way of making it difficul

ons (COFO) launches a massive effort to register black voters during what will become known as the "Freedom Summer.

e Gulf of Tonkin Resolution authorizes the bombing of Vietnam by U.S. troops. November: Lyndon B. Johnson is electec

rested. December: Martin Luther King Jr. is awarded the Nobel Peace Prize. President Johnson signs the Civil Rights Ac

or, religion, or national origin. VISTA (Volunteers in Service to America) is created as part of the Johnson administration

ionalist and founder of the Organization of Afro-American Unity, is shot to death in New York City. March 7: Voting right

an 2,000 are arrested. July: The Equal Employment Opportunity Commission opens. August 11–16: The Watts Riots in Lo

which enforces affirmative action in all aspects of hiring and employment. The Autobiography of Malcolm X is published

e sent to Vietnam (by July, troops will increase from 75,000 to 125,000). March: The first anti–Vietnam War teach-in is held

ied "folk rock." September: United Farm Workers strike against California grape growers. Herbert Marcuse's Culture and

mational Days of Protest against the Vietnam War; the largest gathering draws 25,000 people in New York City. June: Th

eale and Huey P. Newton. November: Ronald Reagan is elected governor of California and vows to crack down on antiwa

e's hearings on Vietnam, chaired by William Fulbright, are broadcast nationally on TV. First convictions are brought agains

lished. Simon & Garfunkel, the Mamas and the Papas, and the Rolling Stones top the charts. 1967 January: Counterculture

the Night wins best picture. April 19: Stokely Carmichael coins the phrase "Black Power" in a speech in Seattle. June: The

sing military service. June: The U.S. Supreme Court rules that prohibiting interracial marriage is unconstitutional (Loving v

entered in the Haight/Ashbury district of San Francisco. July 12–17: Race riots in Newark leave 26 dead and 1,500 injured

he first African American Supreme Court Justice. October: Antiwar demonstrators march on the Pentagon. November: Jam

s the Massage is published. Aretha Franklin, the Doors, Janis Joplin, and Jimi Hendrix top the charts. 1968 January: Rowar

es becoming increasingly unpopular. President Johnson makes a surprise announcement that he will not run for re-election

t of 1968 (the Fair Housing Act) prohibits racial discrimination in housing. May 12–June 19: Poor People's March

he Democratic presidential nomination. August 26–28: Antiwar demonstrators clash with police at the Democrati

xico City Olympics after giving the black-power salute during the award ceremony. November: Richard M. Nixo

e's The Electric Kool-Aid Acid Test, a narrative of Ken Kesey's Merry Pranksters, is published. Zap Comix is firs

ark riots in Berkeley. June 27: The Stonewall Riots in New York mark the rise of the gay liberation movemen

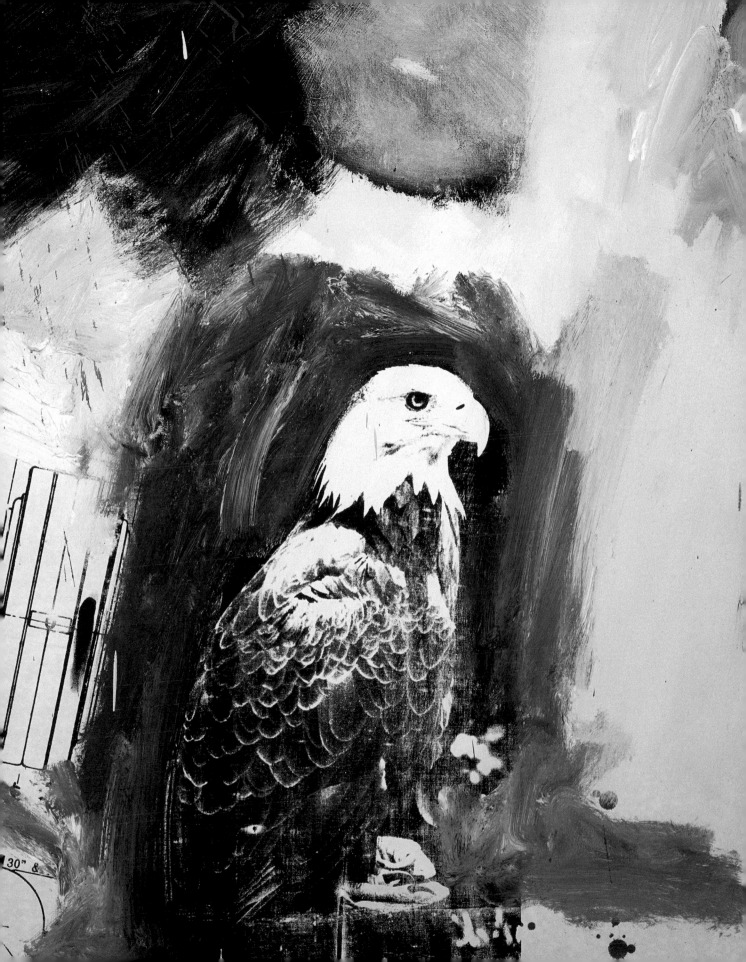

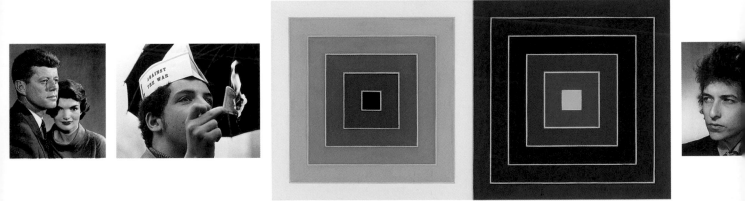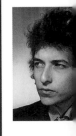

Art&Context

the '50s and '60s

MUSEUM OF ART / WASHINGTON STATE UNIVERSITY
PULLMAN, WASHINGTON

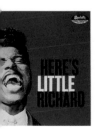

ESSAYS BY
Chris Bruce
Keith Wells

WITH CONTRIBUTIONS BY
Nella Van Dyke

*This exhibition is dedicated to Win Nilan,
a true friend of the arts.*

*This exhibition and publication are made possible
by the generous support of:*

> *The Paul G. Allen Family Foundation
> Richard R. and Constance Albrecht
> Jack and Janet Creighton
> Timothy Manring
> Robert and Winona Nilan
> H. S. Wright III
> and the Visual, Performing, and Literary Arts
> Committee, Washington State University*

*The Museum's exhibition program is supported by the
Friends of the Museum of Art and the Washington State
Arts Commission.*

WASHINGTON STATE
ARTS COMMISSION

THE **PAUL G. ALLEN**
FAMILY *foundation*

N72
.S6
A719
2006

070045881

This publication was produced in conjunction with the exhibition *Art & Context: The '50s and '60s,* organized by Chris Bruce and Keith Wells for the Museum of Art / Washington State University, Pullman. Research assistance was provided by Kristin Ceto, Jeanne Fulfs, Diane Logan, Mary Milcarek, Keena Richardson, Alma Rocha, and Allyson Wolf.
Museum of Art / Washington State University
September 29–December 16, 2006

Copyright © 2006 Museum of Art / Washington State University
All rights reserved. No part of this publication may be reproduced or transmitted in any form or by any means without prior written permission from the publisher.

Distributed by Washington State University Press
PO Box 645910, Washington State University, Pullman, WA 99164-5910
http://wsupress.wsu.edu

Library of Congress Cataloging-in-Publication Data
Art & context : the '50s and '60s / essays by Chris Bruce, Keith Wells ;
 with contributions by Nella Van Dyke.
 p. cm.
 Catalog of an exhibition at the Museum of Art, Washington
 State University, Sept. 29–Dec. 16, 2006.
 Includes bibliographical references.
 ISBN 0-9755662-2-9 (hardcover : alk. paper)
 1. Art and society—United States—History—20th century—
 Exhibitions. 2. Art, American—20th century—Exhibitions. I. Bruce,
 Chris. II. Wells, Keith. III. Washington State University. Museum of
 Art. IV. Title: Art and context.
 N72.S6A719 2006
 709.73'07479739—dc22 2006018153

Front cover, left to right: *Invisible Man* by Ralph Ellison, published by Random House, New York, 1952; *Tales Calculated to Drive You MAD,* no. 1, October/November 1952, edited by Harvey Kurtzman, published by William Gaines, EC Comics; promotional photograph of Groucho Marx for NBC's radio program *You Bet Your Life,* 1949; first issue of *Playboy,* December 1953, with playmate Marilyn Monroe; *The Crucible* by Arthur Miller, published by Viking Press, New York, 1953; Mark Rothko, *Untitled,* 1950 (page 31); film still, *High Noon,* 1952, starring Gary Cooper and Grace Kelly, directed by Fred Zinnemann, distributed by United Artists
Back cover: Andy Warhol, *Campbell's Soup Cans,* 1968 (page 73)
Page 1: Robert Rauschenberg, detail of *Manuscript,* 1963 (page 55)
Pages 2–3, left to right: John F. Kennedy and Jacqueline Kennedy, 1953; protester burning his draft card, 1965 (photo: Richard Blair); Frank Stella, *Rye Beach,* 1963 (page 53); Bob Dylan, 1964 (photo © Daniel Kramer); *Here's Little Richard* album cover, 1957; Martin Luther King Jr. at the National Conference for a New Politics, Chicago, 1967 (photo: Benedict Fernandez); Charlton Heston as Moses in *The Ten Commandments,* 1956, directed by Cecile B. DeMille, distributed by Paramount Pictures; astronaut Alan Shepard, 1961

Designed by John Hubbard
Edited by Michelle Piranio
Proofread by Sherri Schultz
Color separations by iocolor, Seattle
Produced by Marquand Books, Inc., Seattle
 www.marquand.com
Printed and bound in China by C&C Offset Printing Co., Ltd.

Contents

Robert Motherwell, detail of *The French Line*, 1960 (page 45)

This very special project brings together great works of art viewed within the context of a period of dynamic change in American art and society. It is a fitting representation of the Museum of Art's ambition to make world-class examples of creativity and innovation accessible to our audiences and to celebrate Washington State University's goal of nurturing interdisciplinary learning opportunities through the arts.

One can argue that the 1950s and 1960s set the stage for our world today. It was during this time that the mass delivery of television, advertising, and popular culture took hold. It was also the moment when the specter of mass destruction that defined the cold war started to have a pervasive influence on world affairs. Mainstream culture gave way to counterculture. New social, sexual, and racial freedoms were fought for and explored, along with new artistic freedoms.

The idea for an exhibition utilizing works of art to open doors of perception to this influential era originated with Chris Bruce, director of the Museum of Art. He envisioned this type of "contextual" exhibition as a means of engaging WSU's many disciplines in the arts and humanities in a collective conversation, and we are grateful for his leadership and innovative approach.

Drawing from private collections in the Northwest and furthering the Museum's focus on Northwest cultural resources of national and international distinction, *Art & Context: The '50s and '60s* makes its case using examples of the very best art of the time. Indeed, without the vision and generosity of great art collectors, this exhibition and book would not have been possible. It is a pleasure for me to join Chris in extending our deep appreciation to the lenders

Foreword&Acknowledgments

for sharing their treasures with us: Jane and David Davis, Robert and Shaké Sarkis, Herman and Faye Sarkowsky, Jon and Mary Shirley, Richard Weisman, and Virginia and Bagley Wright.

This endeavor also serves to underscore Washington State University's role as a research institution. Art research was led by curator Keith Wells, who contributed a key essay to this publication and also designed and handled all aspects of the complex installation. His research team of students included Kristin Ceto, Diane Logan, Mary Milcarek, Keena Richardson, and Alma Rocha, and they, along with American Studies graduate student Allyson Wolf, who provided additional research, and exhibition assistant Jeanne Fulfs, compiled the material for the timelines. Associate professor of sociology Nella Van Dyke advised on the social movements and wrote the brief introductions to each period. We are proud of their accomplishments and appreciate their dedication to the project.

At the Museum of Art, we wish to thank the staff for their deep commitment to creating a program of such distinction, especially director Chris Bruce, media and public relations manager Boone Helm, administrative assistant Tonya Murray, assistant director Anna-Maria Shannon, director of development Robert Snyder, and curator Keith Wells. Marquand Books in Seattle oversaw the production of this handsome publication, the third in a series for the Museum. We acknowledge the support and assistance of Ed Marquand, Larissa Berry, Linda McDougall, Marissa Meyer, Marie Weiler, and Carrie Wicks; the elegant clarity of John Hubbard's design; and the sensitive oversight of independent editor Michelle Piranio.

We are boundlessly grateful to Paul Allen and Jo Allen Patton of the Paul G. Allen Family Foundation for their major support, which came at a key, early phase in the development of the project. Robert and Winona Nilan of Pullman provided a generous and crucial match to the Allen Foundation donation. Additional significant funding came from Richard R. and Constance Albrecht, Jack and Janet Creighton, Timothy Manring, H. S. Wright III, and the Visual, Performing, and Literary Arts Committee, Washington State University. The Museum's exhibition program is supported by the Friends of the Museum of Art and the Washington State Arts Commission. We are thankful for the commitment and generous contributions of these individuals and organizations, which made this project possible.

Robert C. Bates
PROVOST AND EXECUTIVE VICE PRESIDENT
WASHINGTON STATE UNIVERSITY

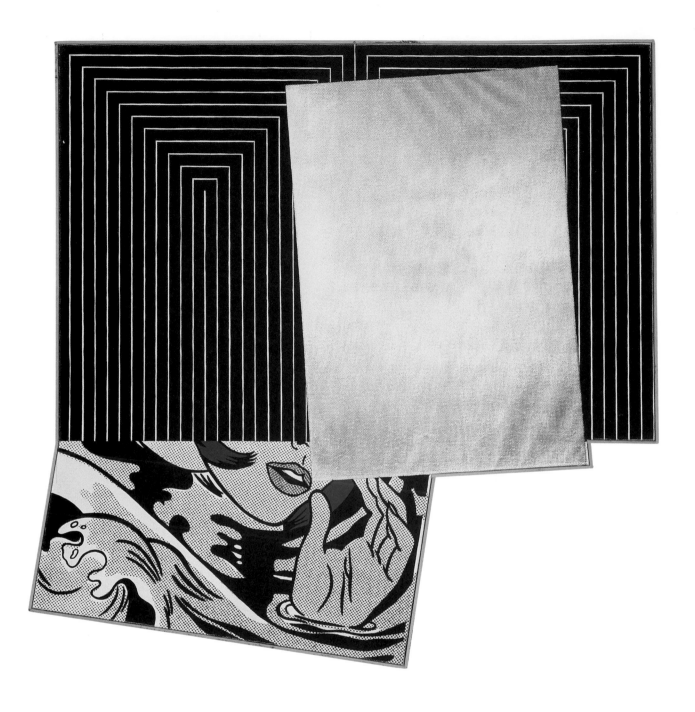

Richard Pettibone
*Marriage of Reason and Squalor, Saturday
Disaster Right Hand Panel and Drowning Girl*
1969
Acrylic on canvas
12½ × 13 in.
Collection of Virginia and Bagley Wright

Something Happened

AN INTRODUCTION TO ART AND CONTEXT IN THE 1950S AND 1960S BY CHRIS BRUCE

The fast-changing, sometimes turbulent decades of the 1950s and 1960s represent a turning point in American history and the history of art. *Art & Context: The '50s and '60s* traces the progress of both art and society from an insular, isolationist, cold war climate to the unprecedented populism and openness that followed. To reflect on how these ideas act in tandem, we have placed the works of art within timelines of their more familiar sociopolitical histories, while still giving them their due as "timeless" objects. Furthermore, this particular period provides an apt framework for examining our current cross-disciplinary, pluralistic world—a time when the "modern" was being replaced by the seeds of the postmodern in both art and life.

The 1950s and 1960s saw the beginning of a historical shift in which old systems were breaking down while new ones were opening the door to unprecedented choices and possibilities. Television invaded our lives and forever changed the way we exchange information and perceive the world. New modes of transportation were making the world "smaller" and more interdependent. It seemed as though we could have it all—or at least have it both ways. While Jack Kerouac was writing about the adventurousness of being on the road, McDonald's and Holiday Inn made it safe and predictable. We could go to the moon and give peace a chance. New advances in chemistry produced the polio vaccine and the birth control pill, which opened new life choices for people all over the planet. LSD opened new doors of perception, which influenced fashion, music, and lifestyles. And a new consciousness about human rights, which had its functional beginnings in 1955 when Rosa Parks took her seat on a bus, would

see millions of Americans take to the streets in the 1960s, demanding unprecedented racial, social, and sexual freedoms and equalities as well as an end to a divisive and, to many, pointless foreign war.

In art, a parallel shift was occurring, from an insular, art-for-art's-sake tradition to a radical new engagement with real-world imagery, materials, and space. *Art & Context* comprises works of art that represent the four primary styles of these two decades—Abstract Expressionism, Color Field painting, Pop art, and Minimalism—and together, these fine examples depict a kind of snapshot of a vital, complex period that has served as a watershed for our own time. And yet it was the Pop and Minimalist artists in particular who did something more than simply react to previous art forms and discourse; instead, they set off a dramatic sequence of changes, whose momentum was truly groundbreaking in terms of redefining where art came from and what it could be. Their influences were arguably as profound as some of the most pivotal developments in art history, in a league with such breakthroughs as the invention of linear perspective, the inception of photography, and the leap into abstraction.

It took a while for the radical impact of these changes to become evident, but in 1983–84, two philosophers—Arthur C. Danto in New York and Hans Belting in Germany—independently came to a similar conclusion: Pop and Minimalist art of the 1960s represented such a fundamental break with previous art history that they considered the developments of this period to be "the end of art."[1] Danto pointed specifically to Andy Warhol's exhibition of *Brillo Boxes* at the Stables Gallery, New York, in the late spring of 1964 as the defining moment. There,

9

visitors found *Brillo Boxes* (art) that looked exactly like Brillo boxes (packaging). For Danto, "the end of art" meant that once you could no longer tell the difference between art and nonart just by looking at a thing, you'd come to the end of a certain kind of (modernist) history that was formally progressive and evolutionary in nature (Impressionism to Post-Impressionism to Fauvism to Cubism and so forth).[2]

Prior to the 1960s, with rare exceptions (notably, Marcel Duchamp's ready-mades earlier in the twentieth century), art objects identified themselves as absolutely distinct from nonart objects. Not only did an Abstract Expressionist painting by Joan Mitchell, for example, depart from "mere reality," it counted on that difference to represent a unique and deeply personal artistic vision. But Andy Warhol's *Campbell's Soup Cans* looked exactly like soup cans and Carl Andre's floor sculptures were, in fact, slabs of industrial metal or firebricks. Art and nonart became virtually indiscernible from each other—except for the context.

In both art and society, what first appeared in the 1950s to be an extreme affirmation of established traditions transitioned, over the next decade, to a new, more open engagement with the world. As social chronicler David Halberstam noted in his fascinating book *The Fifties:*

> *For a while, the traditional system of authority held. . . . During the course of the fifties, as younger people and segments of society who did not believe they had a fair share became empowered, pressure inevitably began to build against the entrenched political and social hierarchy. . . . Others were made uneasy by the degree of conformity around them, as if the middle-class living standard had been delivered in an obvious trade-off for blind acceptance of the status quo. Nonetheless, the era was a much more interesting one than it appeared on the surface. Exciting new technologies were being developed that would soon enable a vast and surprisingly broad degree of dissidence.*[3]

Halberstam's observations could be applied equally to art. In the early 1950s, the "traditional system of authority" would be modern art in general and Abstract Expressionism in particular. There really was very little to indicate that the direction of American art would not continue to develop within the set of attitudes and expectations that had evolved out of Europe from, say, the 1860s, when Gustave Courbet's brushy landscapes so boldly stood against the French Academy and opened the door to Impressionism. Hans Hofmann, who had studied in Paris, and Josef Albers, who had worked at the Bauhaus in Germany with Wassily Kandinsky and Paul Klee, immigrated to the United States in the 1930s and became influential teachers. The American Alexander Calder lived in Paris in the 1930s and was deeply influenced by Piet Mondrian's refined abstraction. Joan Miró's organic Surrealism was channeled through the Armenian émigré Arshile Gorky. Each carried his own version of the same message: continue the path laid out by Cézanne and Picasso—and push it. All of which served to reaffirm the notion of a progressive development of art that sought increasing refinement and purity, which is to say, it sought to distance itself more and more from nonart references.

By the end of the 1940s and into the 1950s, Abstract Expressionist (and, by extension, Color Field) artists had fully succeeded in overturning the centuries-old notion that a painting was a picture of something, and this "negation" was a remarkable, historic achievement. With the exception of Willem de Kooning's *Women* paintings, the old figure-ground relationship was eradicated in favor of an expression of inner worlds and states of mind, a shift of focus that dispensed with any sense of real-world gravity. According to Jackson Pollock, writing in 1950: "The thing that interests me is that today painters do not have to go to a subject matter outside themselves. Most modern painters work from a different source. They work from within."[4] Along the way, there were significant breakthroughs. Pollock broke completely with the tradition of easel painting in favor of

working large-scale on the floor, flinging his paint onto the canvas. Morris Louis, Helen Frankenthaler, and other Color Field painters rejected gestural brushwork in favor of "fields" of poured or stained color that emphasized their materials and the flat plane of the canvas. Calder broke from the pedestal with his Mobiles and opened sculpture to real movement in real time and space. And yet, no matter how dramatic these innovations were, they persisted in signifying themselves within the context of art.

Then came Pop art, with its Brillo boxes, comic strips, and soup cans, and Minimalism, with its plywood boxes, fluorescent tubes, and metal slabs. And the long, evolutionary dialogue about the form of art was replaced by a more radical questioning of what could *be* art. It seemed that art, after abandoning the world of outward appearances, began to realize what it was missing. How could you keep the "real world" out when it was more fantastic than anything fiction or imagination could invent? Poet John Clellon Holmes eloquently described the influences and questions he and his peers encountered in the 1950s:

> The roots of the attitudes that are peculiar to these [artists] are as random and diverse as American life. There are taproots in the movies, comic books, radio and jazz-music. . . . Think of such epiphanies as Chaplin eating his shoe, the sacred and profane dada of Harpo and Groucho, the lift toward ecstasy in a Basie riff, the princely cape beneath Clark Kent's plebian suit. Think of football twilights, the erotic secrecies of boys' rooms, the carnival of neighborhood streets, sad Huck Finn rivers—followed by the disintegrative uprootings of the war, death and euphoria kissing in a Kansas convertible, angels of excess haunting Terre Haute. . . . More on-going origins in the secret excitement of reading Blake, Lawrence, Rimbaud, Céline, Miller, Whitman— having no way to make them respectable to the New Critics, and thus long thoughts about the veracity of that "respectability." Also there was the eruptive,

> mobile, fluctuating nature of American postwar life—streets, bars, pads, bop, drugs, hipsters, sexual breakthroughs, urgings toward any Unknown. . . . Outrageous and unsettling questions started to shape themselves. . . . What did a sonnet really have to do with Hiroshima, Charlie Parker upheavings in the spirit? Could 17th Century meter and rhyme contain the syncopated accelerations of the actual reality of blaring radios and jackhammers and pavement-crowds and bomb-reverberations? How write about real death, under the bitter bridges, in the accents of madrigal?[5]

As American society moved from the prosperity and idealism of the postwar years to the anxiety and upheaval of the cold war era, its culture could no longer be measured in timeless moments of quiet contemplation, reflecting instead a fragmented, distracted attention span. Much of this sensibility was influenced, if not produced, by movies, television, mass media, and the ever-flowing onslaught of *things:* new labor-saving devices, the latest-model Chevy, changing fashions, the swirling vernacular of urban life.

Holmes would answer his own questions with a quote from fellow poet Gregory Corso:

> O I would like to break my teeth
> by means of expressing a radiator![6]

Things—a world full of things. By 1956, Jasper Johns was making paintings of common everyday objects that just happened—brilliantly—to be flat (maps, targets, flags). This allowed him to simultaneously point back to the previous generation's insistence on addressing the flatness of the picture plane while pointing forward to Pop imagery and its engagement with the world around us. By the beginning of the next decade, the art world was full of real-world things: Claes Oldenburg's store was filled with expressive plaster representations of household objects; Allan Kaprow's installations were made of car tires; Jim Dine's canvases included real shoes, coats,

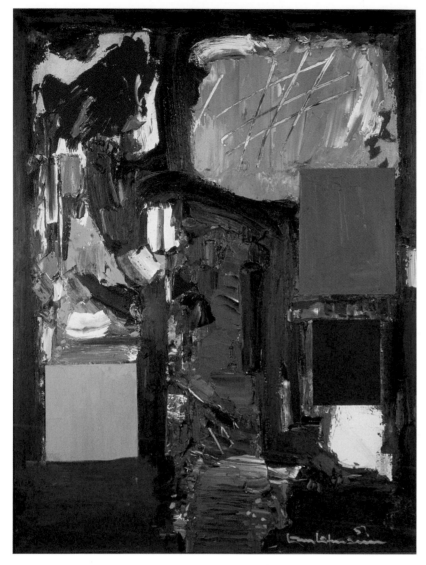

Hans Hofmann
The Bust
1957
Oil on canvas
48 × 36 in.
Collection of Herman and Faye Sarkowsky
© 2006 Estate of Hans Hofmann / Artists Rights
Society (ARS), New York

Opposite:
Robert Rauschenberg
Octave
1960
Combine painting
78 × 43 in.
Collection of Virginia and Bagley Wright
Art © Robert Rauschenberg / Licensed by VAGA,
New York

and ties; John Chamberlain's sculptures consisted of scrap auto parts; and Louise Nevelson's elegantly assembled pieces were made of found wood.

And, of course, there was Robert Rauschenberg, whose art promoted an "epiphany of the everyday."[7] Like Johns, he demonstrated his debt to Abstract Expressionists such as Hofmann while finding sustenance in the world around him. He appreciated his predecessors' emphasis on risk and retained their painterly openness (a signifier of "art" as much as an expression of his own effusive personality). But his sensual appetite was far too expansive and worldly to be limited to searching the subconscious for imagery or meaning. Art critic Brian O'Doherty noted that Rauschenberg's 1963 retrospective exhibition at the Jewish Museum "influenced New York more by *permission* and example than by formal promptings. . . . [I]t opened up not so much possibilities, as *lots of things to do.*"[8] This seemingly all-encompassing "permissiveness" would come to define the future of art. Today we call it pluralism. It was the break art had been looking for—art was no longer about the

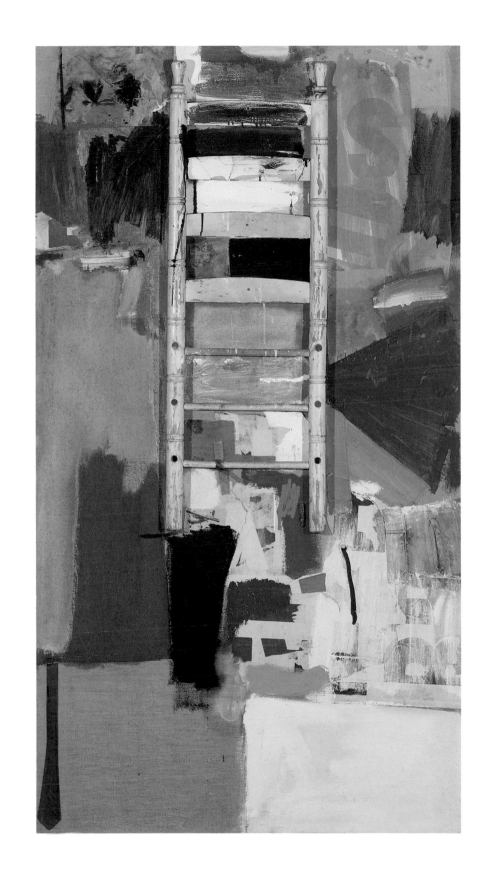

extension of previous forms and styles, but rather an invitation to consider whole new ways of beginning.

Following the transitional examples of Johns and Rauschenberg, the next wave of Pop artists used this permissiveness to radically, almost surgically, eliminate from their work the expressive show of process, which had defined serious art for the last century. Warhol's position was so neutral—so transparent in relation to the sources of his imagery—that he acted as a virtual medium through which all things passed unchanged, except by the nature of their newfound context as art—a philosophical or semantic difference more than a visual one.

Larry Rivers once said about Lichtenstein: "Roy got the hand out of art and put the brain in."[9] For many observers at the time, it seemed as if the Pop artists had gotten the "art" out of art. Most of those who did accept this type of work interpreted it as being a *critique* of the culture it re-presented. Such banal imagery as Brillo boxes, comics, wallpaper patterns, billboards, and celebrity head shots must certainly be functioning as a mirror held up to a consumer-obsessed society. The serial imagery of Warhol's Marilyns and soup cans—and even his more edgy imagery of electric chairs, bomb explosions, and car crashes—must surely stand as a commentary on the effects of endless repetition in a media-saturated culture. Lichtenstein's comics must certainly express the superficiality of American life. For audiences at the time, it would have required an entirely new way of thinking to conceive that a work of art should behave the same way any other commodity might behave. The fact was, as art historian Lawrence Alloway described, "We felt none of the dislike of commercial culture that was standard among intellectuals, but accepted it as fact, and consumed it enthusiastically."[10]

For Danto and Belting, this lack of separation between high and low, art and nonart, is where modern art history "ended" and our pluralistic era began. The art associated with Minimalism only reinforced this position. Pop art had opened itself up to imagery of all kinds, and this had a profound impact on how we viewed the world around us. As Warhol so keenly observed: "Once you got Pop, you could never see a sign the same way again. And once you thought Pop, you could never see America the same way again."[11] For its part, Minimalism embraced an unlimited range of materials (especially industrial ones), processes, and uses of space. Just as Warhol's "manufacture" of artworks in his Factory studio and the burgeoning genres of prints and three-dimensional "multiples" challenged notions of originality, so did Carl Andre's configurations of firebricks, Dan Flavin's use of commercial fluorescent tubes, and Donald Judd's industrially manufactured sculptures. Both Pop and Minimalism embraced a formal structure that relied on repetitive imagery, or *seriality.* You could have a work consisting of four of Warhol's *Campbell's Soup Cans,* or thirty-two; you could have one of Judd's aluminum boxes, or one hundred. Pop and Minimalism, in tandem, not only changed ideas about what art could look like but also shattered long-held ideas about uniqueness and the role of the creative individual. By 1969, Richard Pettibone was making overtly postmodernist works that combined imagery from previous works of art into his own "unique" compositions (see page 8).

In 1974, Chris Burden, then a brash young performance artist from southern California, confidently announced, "Art is a free spot in society, where you can do anything."[12] At the time, his statement seemed a holdover from some free speech manifesto from Berkeley, circa 1965, but it was, in fact, as succinct a definition as anyone has yet come up with regarding the posthistorical free-for-all we now take for granted. Simply put, art stopped obsessing about art and began to grapple with the vast, permeable borderline between art and everyday life. In the wake of Pop art and Minimalism, we might stop to ask ourselves as we walk down the street: Is that a billboard or a work of "art"? Is that pile of broken glass on the sidewalk debris or a site-specific installation piece?

The resonance of this break with the past continues to spiral outward. Its effect on us today is manifest in an ongoing reconsideration of what Danto referred to as a "master narrative" of art, including a reexamination of, among other things, the role of women artists, Mexican muralists, outsider art, and the Harlem Renaissance as well as the impact of photography, design, and graffiti. Indeed, in some circles of academia, the study of art history has been supplemented or even supplanted by visual culture programs, art thus replaced by "visual systems." For example, at the University of Pennsylvania, art history survey classes have been reworked to include not only painting and sculpture but also cartography, photography, and cinema, "to highlight the rise of the public sphere of visual culture, culminating with TV and the Internet."[13] Several programs, including those at Columbia and Wesleyan, have dispensed with art history textbooks altogether. In this view, art history is considered to be an unnecessarily isolated, or isolat*ing*, inquiry. As with asking a fish to define "wet," visual culture theorists question whether art historians are capable of asking the most fundamental question of art (what is it?) precisely because their basic assumption is that it is nothing other than "art."

The danger here is that we overcompensate for the perceived limitations and insularity of art history and ignore its lessons and array of options, or simply get them by osmosis. In discussing this current trend, Los Angeles–based artist Frances Stark has noted that "Connoisseurship in the arena of pop culture is encouraged; it's acceptable to reference the record collection, but not the bookshelf [or art] on the wall."[14] This is not unlike what artists were exploring in the 1960s, and it's barely a nuance removed from what Danto concluded: "To say art history is over is to say that there is no longer a pale of history for works to fall outside of. Everything is possible. Anything can be art."[15]

This small exhibition and book thus aim to represent a time when those who visited the art world must have wondered whether they'd entered through a revolving door that kept depositing them back into the "real" world from which they came. Our project traces the evolution from a period of extreme insularity in artistic discourse to a radical tilting of the axis of the art world toward the diversity of options that the world itself offers up on a daily basis. And yet, let us reinforce this: the notion that nothing is outside the range of possibility, that anything *can* be art, does not mean that everything *is*. And that, it seems to me, remains the operative point of mystery and wonder about, well, for want of a better word, "art."

NOTES

1. See Arthur C. Danto, "The End of Art," in Berel Lang, ed., *The Death of Art* (New York: Haven Publishers, 1984); and Hans Belting, *The End of the History of Art?*, trans. Christopher S. Wood (Chicago: University of Chicago Press, 1987), first published in German by Deutscher Kunstverlag, Munich, 1983.

2. See Arthur C. Danto, *Beyond the Brillo Box: The Visual Arts in Post-Historical Perspective* (New York: Farrar, Straus, Giroux, 1992), 5, 10, 225–29.

3. David Halberstam, *The Fifties* (New York: Fawcett Columbine, 1993), x–xi.

4. Quoted in Donald Judd, "Abstract Expressionism" (1983), reprinted in *Chinati Foundation Newsletter* 6 (December 2001): 8.

5. John Clellon Holmes, "Unscrewing the Locks: The Beat Poets," in Neil A. Chassman, ed., *Poets of the Cities of New York and San Francisco, 1950–65*, exh. cat. (New York: E. P. Dutton and Dallas Museum of Fine Arts, 1974), 65.

6. Gregory Corso, quoted in Holmes, "Unscrewing the Locks," 69.

7. Lana Davis, "Robert Rauschenberg and the Epiphany of the Everyday," in Chassman, *Poets of the Cities*, 40.

8. Brian O'Doherty, *American Masters: The Voice and the Myth* (New York: Random House, 1973), 194.

9. Quoted in Michael Kimmelman, "At the Met with Roy Lichtenstein," *New York Times,* March 31, 1995.

10. Quoted in Ingrid Schaffner, *The Essential Andy Warhol* (New York: Wonderland Press, 1999), 25.

11. Quoted in ibid., 14.

12. Quoted in Jan Butterfield, "Through the Night Softly," *Pacific Sun,* April 18, 1974, 66.

13. Alexandra Peers, "Canon Fodder," *Art News* 105, no. 2 (February 2006): 126.

14. Frances Stark, "Los Angeles," *Artforum* 44, no. 4 (December 2005): 226.

15. Arthur C. Danto, *After the End of Art: Contemporary Art and the Pale of History* (Princeton, N.J.: Princeton University Press, 1997), 114.

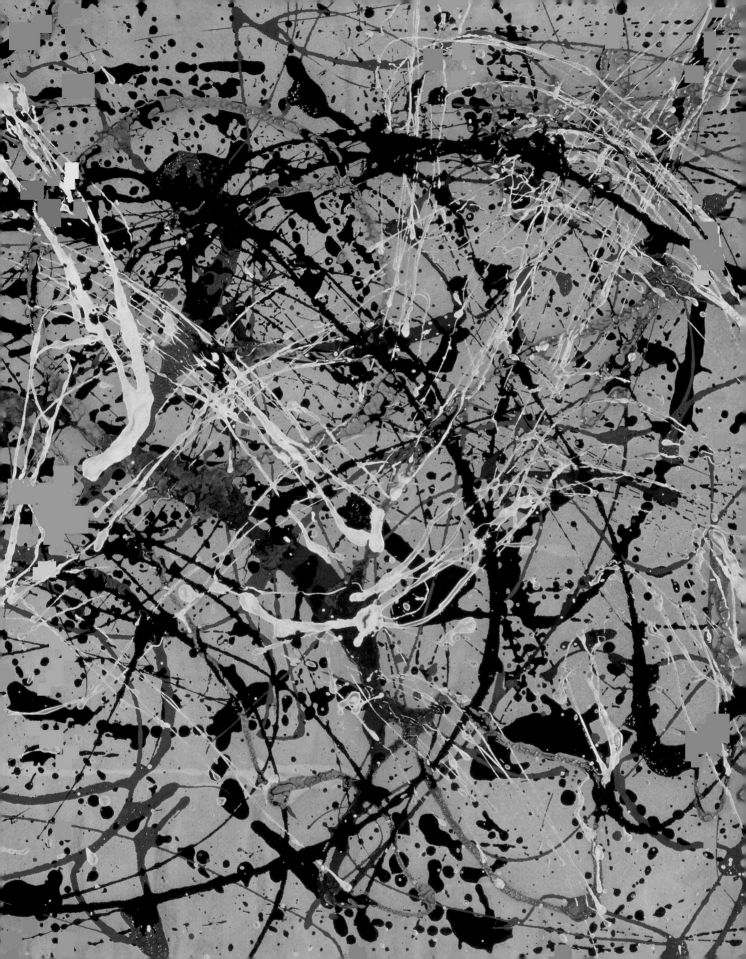

The Echoes of Influence

BY *KEITH WELLS*

It seems to me that modern painting cannot express our era (the airplane, the atomic bomb, the radio) through forms inherited from the Renaissance or from any other culture of the past. Each era finds its own technique.

—JACKSON POLLOCK

The 1950s and 1960s were perhaps the most decisive decades in the development of American modern art. As we try to understand what made the era such a fertile backdrop for the artists of the time, we need to keep in mind the sense of urgency and anxiety that followed in the wake of the Great Depression and World War II, as well as the social changes this country was experiencing. It is difficult to determine which, if any, of the events or ideas that wove through that particular fabric of time most influenced the artist's hand. However, if we are assessing the context of the work created during that period, we cannot ignore the importance of direct influences from the academic institutions, writers and critics, and galleries that brought the art into the public arena, as well as the artists themselves, who not only influenced one another's work stylistically but also formulated some of the postwar critical discourse.

These influences not only changed the course of modern art but also compelled the artists of the time to establish an American idiom and finally break with the School of Paris, which had dominated the avant-garde since the Impressionists laid the foundation for modernism by breaking away from traditional painting in the middle of the nineteenth century. Without the advocacies of many profound thinkers and dedicated promoters who sought to shape and articulate the art of their time, the history of the American avant-garde at midcentury might have played out quite differently.

Institutions and Revolutions in the 1950s

The seeds of the New York School, which was aptly named by Robert Motherwell to connote the shift from the School of Paris, were planted in the wake of the controversial Armory Show of 1913, which shattered the provincial calm of American art. The Armory Show is regarded as a defining moment in the history of American art and a prelude to a radical break with tradition, out of which emerged new and vital visual arts, literature, music, and drama. This exhibition, which featured Europe's finest modern artists, inspired and motivated American artists to free themselves from traditional constraints.

With a burgeoning culture of American artists hungry for exposure to modern ideas and art practices, and many European artists coming to America to escape the anxious climate between the wars, the time was right for New York to claim its position as the new epicenter of the avant-garde. One key factor in this shift was the presence of many émigré artists, who assumed roles teaching art when they arrived in the United States. Hans Hofmann opened his own school on West Ninth Street in New York, and Josef and Anni Albers (after leaving Germany at the close of the Bauhaus in 1933) were among the first Black Mountain College professors.

Founded in 1933, Black Mountain College was a small alternative school in North Carolina. Known for its artistic experimentation and lack of a grading system, it attracted students from all over

the country. Within a short period of time, the college had built up a faculty of artists and intellectuals that included, along with the Albers, John Cage, Merce Cunningham, Willem de Kooning, Buckminster Fuller, Walter Gropius, Alfred Kazin, Jacob Lawrence, and Motherwell. Most of these artists brought the pioneering ideas and processes of Black Mountain College back to New York, to the Eighth Street School (also known as the Club), at 35 East Eighth Street. The Club's renowned summer lecture programs of the late 1940s and early 1950s included talks by notable alumni of Black Mountain College such as John Chamberlain, Robert De Niro Sr., Ray Johnson, Kenneth Noland, Joel Oppenheimer, Robert Rauschenberg, Cy Twombly, and Susan Weil. Black Mountain College closed in 1956, but its breaking of aesthetic boundaries had a lasting impact. It was at these institutions that performance art pioneers such as Allan Kaprow and John Cage fanned the fires of creative activity with anxious demonstrations of human spontaneity, while Action painters traded the traditional master's control of the brush for the assisted accident of pouring and dripping paint.

Driven by ideas originating at these institutions, a revolution began that would change the face of American art. The first coup took the form of a protest against a statement made by James S. Plaut, the director of the Institute of Modern Art in Boston. In 1948, Plaut wanted to change the word "modern" in the institute's name to "contemporary" and defended his suggestion by making a statement that condemned modern art as an obscure and negative academic style that refused to communicate with the public. Local Boston artists gathered in protest at the institute, but a larger and more organized group of artists, assembled by painter Paul Burlin, gathered at the Museum of Modern Art in New York to protest Plaut's statement and to denounce critics who supported him. A second and more notorious protest came two years later, when the Metropolitan Museum of Art in New York planned to have a national jury for its exhibition *American Painting Today—1950*. The "Irascible Eighteen," which included William Baziotes, de Kooning, Adolph Gottlieb, Hofmann, Motherwell, Barnett Newman, Jackson Pollock, Ad Reinhardt, Mark Rothko, and Clyfford Still, sent an open letter to Roland Redmond, president of the Metropolitan Museum, accusing him and the juries involved of harboring hostilities toward advanced modern art. The eighteen artists vowed not to submit works to the competition, thereby denying it the participation of some of the most important artists of the time. This protest generated widespread interest and press coverage, including the now famous photograph of the Irascibles in *Life* magazine, which piqued America's curiosity about modern art.

In reaction to such public interest and visibility, there were many attempts to articulate goals and specific aesthetic aims, and regular meetings were held at the Club or the Cedar Tavern in Greenwich Village; but "agree to disagree" became the unwritten motto of this group of highly diverse artists. Nonetheless, the Abstract Expressionists of the New York School had set the pace for modern art; critics and theorists stepped in to sort things out. Armed with lengthy manifestos on the future of modern art, Cubist and Surrealist influences, and Duchampian theory, these writers shaped the polemical structure of art criticism and drew their lines in the sand somewhere between "taste" and innovation.[1]

Tastemakers and the Intelligencia

Early twentieth-century critics such as Alfred Barr and Meyer Schapiro had laid the foundation for thoughts on abstract painting in the mid-1930s. Barr's 1936 book *Cubism and Abstract Art* categorized and described the movements grouped under the banner of abstract art with few judgments or assumptions, concluding that abstraction came about because representational art had been exhausted. Schapiro, using Barr as a point of departure, set out to illuminate the significance of abstraction. In a 1937 essay titled "The Nature of Abstract Art," he wrote:

Before there was abstract painting, it was already widely believed that the value of a picture was a matter of colors and shapes alone. Music and architecture were constantly held up to painters as examples of a pure art which did not have to imitate objects but derived its effects from elements peculiar to itself. But such ideas could not be readily accepted (in painting), since no one had yet seen a painting made up of colors and shape representing nothing. . . . In abstract art, however, the pretended autonomy and absoluteness of the aesthetic emerged in a concrete form. Here, finally, was an art of painting in which only aesthetic elements seem to be present.[2]

By placing the aesthetic purpose of abstract painting in the same context as music and architecture, Schapiro set the framework for a new approach to understanding and evaluating abstract art.

The new art of this generation was considered by most as symptomatic of a crisis, but it was in the perception of it being a threat that the strength of it was revealed. If it were simply bad painting, it would have been easily forgotten. Clearly, it was much more, and that suggested that the parameters of traditional aesthetic theory were inadequate to describe or contain modern art. Critic Harold Rosenberg and Cage were among the first to tackle the arduous chore of making sense of the modern agenda, but it was Motherwell and Reinhardt who produced *Modern Artists in America* in 1952, a journal whose aim was not to promote artists but to dispel misunderstandings about modern art and to report on new developments.

It was useful to have a forum to exchange ideas, but it became clear that for the revolution to be successful it needed a defining leader. That position was filled by Clement Greenberg, one of the most influential critics at midcentury and a staunch advocate of Abstract Expressionism. His writings on the movement, which appeared in *The Nation* and *Partisan Review*, dominated the New York art world so powerfully that artists were generally divided into two groups: those who adhered to his principles, and those who set themselves sharply against him. In either case, he was a figure whose ideas animated the work of many artists.

As early as 1939, in his essay "Avant-Garde and Kitsch," written for the *Partisan Review*, Greenberg maintained that the objective of all modernist painting, from its roots in Impressionism on, was to become "pure."[3] In this view, artists should seek an art based on the direct properties of painting and surrender to their medium, keeping the emphasis on color and the two-dimensional plane on which the paint is applied. Greenberg argued that tonal value, depth, and modeling worked against pictorial flatness, and so he rejected painting with imagery because of its illusionist spatial qualities. It is for this reason that he championed the Abstract Expressionists in the 1950s and the Color Field painters in the 1960s (the latter he grouped under the banner of Post-Painterly Abstraction).

Although Greenberg was notorious for changing his stance on various issues and constantly redistributing his loyalties among historical as well as contemporary artists and styles, he remained adamant that there was a "truth" in painting that must come from letting go of the innate inclination to control the medium. He maintained that each artist has a unique physical interaction with the materials, the result of which is the core of his or her style. This notion was well received by many of the Abstract Expressionists simply because it implied that since there was truth, there must also be some sense of honesty, which allowed for there to be an intention or goal rather than an arbitrary eruption of creative execution.

By contrast, Rosenberg, in his writings on Action painting, placed emphasis on the *event* of painting. Unlike Greenberg, who was concerned with formal values and held the opinion that "the main function of criticism was to sort the good art from the bad,"[4] Rosenberg believed that the critic's role was to assess the artist's ability to dismiss all traditional constraints and reduce the process of painting to an existential episode. It is for this reason that he

also embraced gesture painters such as de Kooning, who approached painting from an unpremeditated position, free from preconceived notions about the medium itself or from his own life experiences.

To some degree, Greenberg had a Midas touch. Because he was considered the final word in "taste" when it came to modern painting, he had a strong influence over curators and collectors. Quite often, a nod from him was enough to secure an artist's career. Some even argue that Greenberg not only helped articulate the work of the artists of the New York School but also influenced the direction of their work. Not one to mince words or withhold (what he considered to be) good advice, he often made suggestions to artists in his fold. It was said to be at his urging that Pollock abandoned his early gestural figurative work in favor of a flat, "allover" type of abstraction and that Color Field painters such as Helen Frankenthaler and Morris Louis pursued their techniques of pouring and soaking thinned paint on unprimed canvas. Between his published writings and personal relationships with the artists themselves, Greenberg was perhaps unmatched in influencing the development of American art in the postwar years.

Gallerists and Galleries in the 1960s

Whereas Abstract Expressionism was bolstered and even influenced by intellectuals and critics such as Rosenberg and Greenberg, Pop art in the 1960s was generally scorned by critics. The artists that emerged in response to the Abstract Expressionists were championed instead by discerning and dedicated gallerists.

In the early postwar years, the business of dealing in modern art was, at best, a risky endeavor, and though numerous gallerists, notably Peggy Guggenheim and Howard Putzel in the 1940s and Samuel Kootz and Betty Parsons in the 1950s, supported emerging artists at the time, none had the impact that Leo Castelli would have in the 1960s. Castelli was legendary for his almost prophetic ability to see potential in an artist and find a market for it, and in

1961 he cracked the lid on Pop art, one of the most enduring movements in American art history.

Pop art emerged somewhat naturally following the overstimulation of consumerism in the 1950s. It began in Great Britain as a small movement of artists who used imagery from popular culture, including advertising and the mass media. The American version had no specific association with the British movement and operated quite differently as an all-inclusive display of the pervasive and mundane imagery of America's mass-market culture. It acted not so much as a judgment of this culture but as an almost celebratory embrace of the democratization it implied. Artists such as Andy Warhol simply observed culture and found images that were easily identifiable but acted as semiotic vehicles of Americana. The potential of the image lay in its capacity to both unify and separate viewers. The general public may have had some collective experience of a can of Campbell's soup, but the experiences, good or bad, were ultimately personal.

Whereas the Abstract Expressionists were making individualized statements of autonomous creativity, the Pop artists looked to commonly experienced imagery, devoid of personal expression, from the world around us. There was a playful familiarity in Pop imagery that didn't require analytical articulation by critics and theorists. Defying Greenberg's ideas, Pop artists turned to the banal as subject matter for their art, visually sampling the objects and images that were redefining the cultural identity of America in the 1960s. Though the Pop movement can be seen in many ways as a reactionary response to Abstract Expressionism, artists such as Rauschenberg, Jasper Johns, Jim Dine, and Larry Rivers straddled the two approaches by combining gestural brushwork and Pop subject matter, creating a visual bridge from one movement to the next.

Pop art in America owes something of its stature to the guidance and devotion of Leo Castelli. Many

Andy Warhol, detail of *Campbell's Soup Cans,* 1968 (page 73)

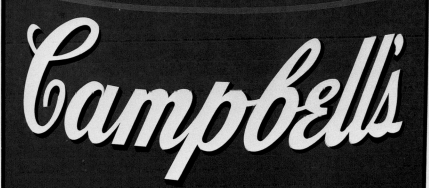

of the Pop artists, including Warhol and Rivers, had exhibited work at the Sidney Janis Gallery, the Stable Gallery, and the Bodley Gallery, among others, during the late 1950s. These galleries recognized the individual importance of the works, but no significant cohesiveness was established among the artists. Castelli pinpointed a deeper connection among numerous artists who were working oblivious of one another and yet all using imagery from mass culture. He gave Johns his first solo exhibition in 1958, after seeing his work in Rauschenberg's studio; the show was a legendary success, with four works sold to the Museum of Modern Art. In 1962, he offered a young Roy Lichtenstein his first solo show. Warhol would exhibit at the Castelli Gallery starting in 1964, and other artists in Castelli's fold included Claes Oldenburg and James Rosenquist.

Castelli also embraced the Minimalist movement and was an advocate for artists such as Donald Judd, Robert Morris, and Frank Stella. Although Minimalism sought to strip forms down to their most elemental structures, Castelli may have seen an artist such as Johns as a bridge between Pop and Minimalism, and he was able to connect the two camps by virtue of the impersonal nature of both groups' images. Both movements were reacting against the subjective elements of Abstract Expressionism, and this afforded them a certain camaraderie. In the same way that Greenberg can be considered the oracle of the 1950s, Castelli had his finger on the pulse of the 1960s.

Artists Influencing Artists

There is one final, more elusive consideration to be made in looking at the wealth of art practices arising in the 1950s and 1960s: the inspiration that artists give other artists. Among the members of the various movements, there was a genuine sense of solidarity and camaraderie that must also have been a driving force behind the work. In addition, a number of artists during these formative decades contributed significantly to the criticism and theory.

Artists are commonly influenced by their mentors and historical figures, but what made the New York School so dynamic was the mutual inspiration and stimulation they provided to one another. Motherwell, Reinhardt, Hofmann, and Cage were among the artists who contributed some of the most important discourse about American art at midcentury. By example and in theory, they broke down the barriers and opened doors for many other artists by creating works that challenged the mind as well as the established ideas about aesthetics. Motherwell and Reinhardt both were active in writing criticism and theory about Abstract Expressionism. Hofmann's winter lectures, held at his school in New York in 1938–39, were attended by important figures such as Arshile Gorky and Greenberg. Pollock, of course, was simply larger than life, and though huge personas could propel the legendary status of an artist, the art was the primary influence. As Kenneth Noland later observed:

> With artists of my own generation there was at first no group identity—and never a clique. In the '50s Morris Louis and I were not known, David Smith and Helen Frankenthaler were not much known. Pollock was known, certainly, but for all the wrong reasons. He was known as much for being wild and unconventional in his working methods as for being a great artist—"Jack the dripper" and all that. Morris and I knew Pollock was THE most interesting artist around in the forties & fifties. We knew it not from his actions but from his art. . . . We also knew Hans Hofmann as a teacher and earlier on I had taken Morris to New York to meet critic Clement Greenberg. He was a catalyst because he had written about and pointed toward the best artists, past and present. Their influence was like soul food for Morris and me.[5]

A serendipitous side effect of the creative fervor of the 1950s and 1960s was cross-disciplinary exchange. Poet Frank O'Hara, dancer Merce Cunningham, performance artist Allan Kaprow, and composer John

Cage all made major contributions to the visual art components. Whether writing about art or incorporating aspects of it in their work, they definitely added fuel to the fire and in the process became strong influences. Cage is a revealing example of the interdisciplinary fervor of the time, as his often challenging ideas applied to all forms of creative practice. He was a faculty member at Black Mountain College during the 1948 and 1952 summer sessions and collaborated often with artists, including Kaprow and Motherwell. Cage's 1952 performance piece titled *4' 33"*, in which David Tudor sat in front of a piano for four minutes and thirty-three seconds and played nothing, was "a distillation of years of working with found sound, noise and alternative instruments. In one short piece, Cage broke free from the history of classical composition and proposed that the primary act of musical performance was not making music, but listening."[6] This important performance helped to dismantle the remaining barriers of the avant-garde and is counted as a stark contribution to the permissiveness that would characterize subsequent generations of artists.

The Minimalist movement also produced a number of artist-philosophers, and much of its discourse was driven by the writings of Donald Judd and Robert Smithson, among others. Judd wrote criticism for Thomas Hess's journal, *Art News*. His reviews of artists helped him to hone his ideas about his own work. One of Judd's most important concepts, to which he constantly returned, was the observation that looking at an object conjures a response or feeling, but that response is *brought* to the object—there is no feeling that exists within the object itself. This profound perception precipitated much of the postmodern discourse that would follow.

Avant-garde artists of the 1950s and 1960s embarked on visual experiments that seemed at times to defy explanation or validity, at least by traditional standards, but they were quickly championed by those who perceived the expanding art culture as a collective of existential gestures, pure aesthetics, and ever-expanding permissiveness. The academic institutions, critics, gallerists, and artists who boldly identified, articulated, and exhibited the art of this tumultuous and exciting period were crucial in securing the future of modern art in the United States. The ramifications of this era—in both art history and history at large—have been influencing artists ever since.

NOTES

1. The word "taste" was used frequently at the time to describe the discerning eye of the well-educated connoisseur.

2. Meyer Schapiro, "The Nature of Abstract Art," in *Modern Art: 19th and 20th Centuries, Selected Papers* (New York: George Braziller, 1979), 185.

3. See Clement Greenberg, "Avant-Garde and Kitsch" (1939), reprinted in Charles Harrison and Paul Wood, *Art in Theory: An Anthology of Changing Ideas* (Oxford: Blackwell, 1994), 529–41.

4. Irving Sandler, *The Triumph of American Painting: A History of Abstract Expressionism* (New York: Praeger, 1970), 274.

5. Kenneth Noland, "Context," speech delivered at the University of Hartford, March 1988, available online at http://www.sharecom.ca/noland/nolandtalk.html.

6. From "John Cage," *American Masters*, PBS, http://www.pbs.org/wnet/americanmasters/database/cage_j.html.

1950–55

THE COLD WAR, MCCARTHYISM, AND CONFORMITY CULTURE

1950 January: President Harry S. Truman initiates a crash program to develop the hydrogen bomb. February: At a Republi[can] [w]omen's club in Wheeling, West Virginia, Senator Joseph McCarthy makes an incendiary speech, claiming that the U.S. S[tate] [D]epartment has been infiltrated by communist spies. During the Red Scare of the 1950s, the House Un-American Activi[ties] [C]ommittee (HUAC) will persecute suspected Communist Party members. Among the thousands of people blacklisted are L[ena] [H]orne, Paul Robeson, Arthur Miller, and Dashiell Hammett. May: U.S. sends 35 military advisors to Vietnam. June: The Kor[ean] [W]ar begins when North Korea invades South Korea, using Soviet military equipment. Under the leadership of General Dou[glas] [M]acArthur, the United Nations Command joins the fight with thousands of U.S. troops. October: Communist China joins fo[rces] [w]ith North Korea in the Korean War. Levittown is built on Long Island, and 17,400 homes go up for sale; the developm[ent is] nicknamed "Fertility Valley" and the "Rabbit Hutch" because of the rapid growth, with 40 houses a day being built at [the p]eak of construction in 1949–50. 9% of U.S. homes have television sets. 1951 March: Estes Kefauver's Senate hearings [on o]rganized crime (which began in May 1950) are broadcast live on national television. At the height of McCarthyism, Julius [and] [E]thel Rosenberg are convicted of espionage against U.S.; they are executed by electric chair in June 1953. October: I L[ove] [L]ucy premieres on TV. 1952 August: Kemmon Wilson opens the first Holiday Inn in Memphis. September: Richard Nixon, [in] [h]is "Checkers speech," portrays himself as a man of the people and saves his political career. October: The Adventures of O[zzie] [a]nd Harriet premieres on TV. November 1: First successful test of the hydrogen bomb is conducted near the Marshall Isla[nds.] November: Dwight D. Eisenhower, the former Supreme Commander of the Allied Forces in Europe during World War I[I, is] [e]lected the 34th president over Democrat Adlai Stevenson. November 16: John Clellon Holmes uses the term "Beat Generat[ion]" [in] his article "This Is the Beat Generation" in the New York Times Magazine. The B-52 bomber is developed. Sam Phillips op[ens] [S]un Records in Memphis. He initially records Southern black musicians, but by the mid-1950s is promoting a fusion of black [and] [c]ountry music with recordings by Elvis Presley, Johnny Cash, and Carl Perkins, among others. First issue of MAD magazi[ne is] [p]ublished (the character of Alfred E. Neuman is introduced four years later). 1953 January: Arthur Miller's The Crucible, w[hich] [u]ses a witch trial as a metaphor for McCarthy's communist "witch hunts," is first performed on Broadway. February [27:] [T]he Korean War is signed in Panmunjon. During the war, approximately 54,000 American soldiers d[ie] [a]nd 103,000 are wounded. March: Joseph Stalin dies; in September, Nikita Khrushchev is named First Secretary of the US[SR.] August 12: The USSR explodes the hydrogen bomb at the Semipalatinsk Test Site, Kazakhstan. The CIA, in a covert action, h[elps] [t]o overthrow the Iranian government headed by Mohammad Mosaddeq and installs Shah Mohammad Reza Pahlavi in 1954. [Ian] [F]leming's Casino Royale, the first James Bond book, is published. The first issue of Playboy is published. 1954 May: French tro[ops] [p]ull out of Vietnam. May: U.S. Supreme Court overturns "separate but equal" and rules that public school segregation is ill[egal (]Brown v. Board of Education of Topeka, Kansas). June: Senator McCarthy is censured by the U.S. Senate. The CIA instig[ates] [a] coup in Guatemala to stop the spread of communism in Latin America. The first issue of Sports Illustrated is published. M[ore] [t]han one-half of U.S. homes have TVs (an estimated 26 million). Disneyland and Lassie premiere on TV. 1955 January: U.S. be[gins] [s]ending foreign aid to the southern-based Republic of Vietnam. April: Jonas Salk's polio vaccine is introduced to the public. [Bill] [H]aley records "Rock Around the Clock." May 7: Rev. George Lee, an advocate for black voting rights, is murdered in Bel[zoni,] [M]ississippi. August 13: Lamar Smith, a World War II veteran and organizer of voter registration drives in the black commu[nity,] [is] murdered in Brookhaven, Mississippi. August 28: Fourteen-year-old black Chicagoan Emmett Till, while visiting fami[ly in] [M]ississippi, is kidnapped, brutally beaten, shot, and dumped in the Tallahatchie River for allegedly whistling at a white wom[an.] [T]wo white men, J.W. Milam and Roy Bryant (the woman's husband), are arrested for the murder and acquitted by an all-w[hite] [j]ury. Sept. 30: James Dean dies in a car crash at the age of 24. October: The Mickey Mouse Club and The Ed Sullivan S[how] [p]remiere on TV. November: Allen Ginsberg gives his first reading of "Howl" (published in 1956) at the Six Gallery, San Franc[isco.] [D]ecember 1: NAACP member Rosa Parks refuses to give up her seat in the white section of a bus in Montgomery, Alaba[ma.] [D]ecember 5: Dr. Martin Luther King Jr. begins a 54-week bus boycott in Montgomery (it will end on December 20, 1956, w[hen] [t]he buses are officially desegregated following a U.S. Supreme Court ruling). The Warsaw Pact Treaty, officially named [the] [T]reaty of Friendship, Co-operation, and Mutual Assistance, is organized as military support of Soviet interests in Central [and] [E]astern European countries. Simon Rodia completes work on the Watts Towers in Los Angeles, which he began in 1921. [Ray] [K]roc begins franchising McDonald's hamburger stands. Daughters of Bilitis, the first lesbian organization in the U.S., is foun[ded.] [Rebel without a Cause and Blackboard Jungle signal a new market for teen movies. 1956 March: The Southern Manifesto, w[hich] [o]pposes integration, is signed by congressmen from Southern states. March: Elvis records Heartbreak Hotel. It will become [the] [f]irst record to simultaneously be number one on the pop, R&B, and country music charts. June: The Federal Aid Highway [Act] [o]f 1956 authorizes construction of the interstate highway system. September: Grace Metalious's novel Peyton Place is publis[hed.] November: Dwight D. Eisenhower is reelected president. The Japanese American Citizens League successfully passes Propos[ition] [1]3 in California, which returns land rights to Japan-born U.S. citizens. Rock 'n' roll takes hold as Elvis Presley ("Hound [Dog")]

THE 1950S WERE AN UNUSUAL TIME in American history, marked by a strong emphasis on tradition that coexisted simultaneously with the stirrings of a new era. In the aftermath of World War II, Americans sought a return to "traditional" family life to an unprecedented extent, and birth rates soared, producing the baby boom generation. As televisions rapidly made their way into American living rooms, ideas about family life were reinforced by shows such as *The Adventures of Ozzie and Harriet*, which debuted in 1952. The spread of television media along with other technological developments, including the first-ever coast-to-coast direct-dial telephone service, began to transform American life. In the international sphere, the United States entered the decade involved in the Korean War and the cold war. The cold war had an especially profound influence on domestic politics in the first half of the decade, which was dominated by concerns about communist infiltration and threats from within. Political dissent was squelched as first the House Un-American Activities Committee and then the Senate Permanent Subcommittee on Investigations, chaired by Senator Joseph McCarthy, conducted public hearings aimed at rooting out subversives within the government. Highlighting the political climate of the time, two American citizens, Julius and Ethel Rosenberg, were sentenced to death for espionage in 1951; they were executed by electric chair in June 1953.

At the same time that the 1950s saw a return to tradition in American culture, changes set in motion during the previous decade continued to develop. Inspired by increasingly favorable Supreme Court rulings, a nascent African American civil rights movement was preparing to challenge an American culture whose full rewards they had been denied for years. Gay and lesbian communities grew, enabled by urbanization, and formed the first gay rights organizations—the Mattachine Society and the Daughters of Bilitis—in the first half of the decade. Reacting in part to the conservatism of the times, the poets and artists who would become known as the Beat Generation began to lay the groundwork in the early 1950s for a countercultural movement. The rumblings of a challenge were stirring and would continue to grow in the latter half of the decade.

—NVD

January: President Harry S. Truman initiates a crash program to develop the hydrogen bomb.

February: At a Republican women's club in Wheeling, West Virginia, Senator Joseph McCarthy makes an incendiary speech, claiming that the U.S. State Department has been infiltrated by communist spies. During the Red Scare of the 1950s, the House Un-American Activities Committee (HUAC) will persecute suspected Communist Party members. Among the thousands of people blacklisted are Lena Horne, Paul Robeson, Arthur Miller, and Dashiell Hammett.

May: U.S. sends 35 military advisors to Vietnam.

June: The Korean War begins when North Korea invades South Korea, using Soviet military equipment. Under the leadership of General Douglas MacArthur, the United Nations Command joins the fight with thousands of U.S. troops.

March: Estes Kefauver's Senate hearings into organized crime (which began in May 1950) are broadcast live on national television.

At the height of McCarthyism, Julius and Ethel Rosenberg are convicted of espionage against the U.S.; they are executed by electric chair in June 1953.

Remington Rand delivers the first UNIVAC mainframe computer to the U.S. Census Bureau.

August: Kemmon Wilson opens the first Holiday Inn in Memphis.

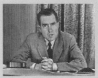

September: Richard Nixon, in his "Checkers speech," portrays himself as a man of the people and saves his political career.

October: *The Adventures of Ozzie and Harriet* premieres on TV.

November: Dwight D. Eisenhower, the former Supreme Commander of the Allied Forces in Europe during World War II, is elected the 34th president over Democrat Adlai Stevenson.

November 1: First successful test of the hydrogen bomb is conducted near the Marshall Islands.

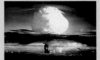

19**50**

19**51**

19**52**

October: Communist China joins forces with North Korea in the Korean War.

Levittown is built on Long Island, and 17,400 homes go up for sale; the development is nicknamed "Fertility Valley" and the "Rabbit Hutch" because of the rapid growth, with 40 houses a day being built at the peak of construction in 1949–50.

9% of U.S. homes have television sets.

October: *I Love Lucy* premieres on TV.

November 16: John Clellon Holmes uses the term "Beat Generation" in his article "This Is the Beat Generation" in the *New York Times Magazine*.

The B-52 bomber is developed.

Sam Phillips opens Sun Records in Memphis. He initially records Southern black musicians, but by the mid-1950s is promoting a fusion of black and country music with recordings by Elvis Presley, Johnny Cash, and Carl Perkins, among others.

First issue of *MAD* magazine is published (the character of Alfred E. Neuman is introduced four years later).

January: Arthur Miller's *The Crucible,* which uses the Salem witch trials as a metaphor for McCarthy's communist "witch hunts," is first performed on Broadway.

February 19: The Korean War truce is signed in Panmunjom. During two and a half years of fighting, more than 54,000 American soldiers died and 103,000 were wounded.

March 5: Josef Stalin dies; in September, Nikita Khrushchev is named First Secretary of the USSR.

May: French troops pull out of Vietnam.

U.S. Supreme Court overturns "separate but equal" and rules that public school segregation is illegal (*Brown v. Board of Education of Topeka, Kansas*).

June: Senator McCarthy is censured by the U.S. Senate.

The CIA instigates a coup in Guatemala to stop the spread of communism in Latin America.

The first issue of *Sports Illustrated* is published.

January: U.S. begins sending foreign aid to the southern-based Republic of Vietnam.

April: Jonas Salk's polio vaccine is introduced to the public.

Bill Haley records "Rock Around the Clock."

October: *The Mickey Mouse Club* and *The Ed Sullivan Show* premiere on TV.

19**53** 19**54** 19**55**

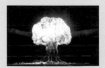

August 12: The USSR explodes the hydrogen bomb at the Semipalatinsk Test Site, Kazakhstan.

The CIA, in a covert action, helps to overthrow the Iranian government headed by Mohammad Mosaddeq and installs Shah Mohammad Reza Pahlavi in 1954.

Ian Fleming's *Casino Royale,* the first James Bond book, is published.

The first issue of *Playboy* is published.

More than one-half of U.S. homes have television sets (an estimated 26 million).

Disneyland and *Lassie* premiere on TV.

The Warsaw Pact Treaty, officially named the Treaty of Friendship, Co-operation, and Mutual Assistance, is organized as military support of Soviet interests in Central and Eastern European countries.

Simon Rodia completes work on the Watts Towers in Los Angeles, which he began in 1921.

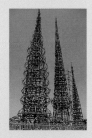

Daughters of Bilitis, the first lesbian organization in the U.S., is founded.

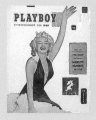

Jackson Pollock

B. 1912, CODY, WYOMING; D. 1956, THE SPRINGS, NEW YORK

Pollock was raised in Arizona and California, and his family moved frequently as his father looked for farm work. Pollock attended the Manual Arts High School in Los Angeles, and it was there that he was encouraged to pursue his interest in art. He followed his older brother Charles to New York, in 1930, to study at the Art Students League under Thomas Hart Benton. Pollock emulated Benton's American Scene style in his work for a short period, but his attention was quickly diverted by the impact of the large-scale mural paintings of Mexican artists José Clemente Orozco and David Alfaro Siqueiros. Pollock had seen Orozco at work on his mural at Dartmouth College, and also enrolled in an experimental workshop taught by Siqueiros in 1936. It was there that he first encountered enamel paints and developed an affinity for flinging and pouring liquid paint to achieve spontaneous results. After joining the Works Progress Administration (WPA) to support his artistic career, he explored several stylistic avenues throughout the 1930s, with the influence of Picasso and Miró surfacing in his paintings. Pollock met his wife, artist Lee Krasner, in 1941. Soon thereafter, he began to gain notoriety as a painter and caught the attention of Peggy Guggenheim in 1945, who gave him his first solo show. She also helped him financially and gave him a loan to buy a small rural homestead in The Springs, East Hampton. In 1947, Pollock returned to the processes he had learned at Siqueiros's workshop and began dripping and pouring layer upon layer of paint onto canvases that were laid flat on his studio floor. Critical response was mixed, but critic Clement Greenberg hailed his work as representing the future of art freed from the constraints of traditional painting. Pollock was catapulted into stardom when he gave an interview for the 1949 *Life* magazine article "Jackson Pollock: Is He the Greatest Living Painter in the United States?" He was plagued with bouts of depression and alcoholism that would shadow him to the end of his life, which was cut tragically short by a car accident.

Jackson Pollock
#20
1949
Oil on paper, on board
20 × 28 in.
Collection of Jon and Mary Shirley
© 2006 The Pollock-Krasner Foundation /
Artists Rights Society (ARS), New York

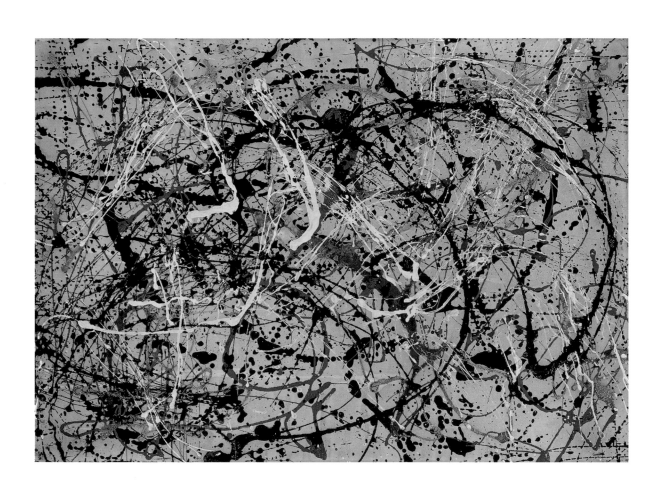

Mark Rothko
B. 1903, DVINSK, RUSSIA; D. 1970, NEW YORK

Rothko left Russia in 1913 and moved to Portland, Oregon. On a scholarship, he attended Yale University from 1921 to 1923, and then moved to New York, where he studied under Max Weber at the Art Students League in 1925. Rothko became close friends with Milton Avery and Adolph Gottlieb in the early 1930s. He was a founding member of the Ten, a group of artists sympathetic to abstraction and expressionism, although he denied emphatically that he was an abstract artist. He worked for the easel painting division of the WPA Federal Art Project from 1936 to 1937. Peggy Guggenheim gave Rothko a solo show at her Art of This Century gallery in New York in 1945. In 1947 and 1949, Rothko taught at the California School of Fine Arts, San Francisco, along with Clyfford Still. In the year between, he cofounded a short-lived art school in New York City along with William Baziotes, David Hare, and Robert Motherwell. Rothko's mature style emerged in the late 1940s and is characterized by flat but luminous rectangles hovering on the surface of the canvas, alluding to atmospheric sensations. Rothko executed his first commission, monumental paintings for the Four Seasons restaurant in New York, in 1958. He completed murals for Harvard University in 1962, and in 1964 accepted a mural commission for an interdenominational chapel in Houston. Rothko committed suicide on February 25, 1970, in his New York studio. The Rothko Chapel in Houston was dedicated the next year.

Mark Rothko
Untitled
1950
Oil on canvas
44½ × 33½ in.
Collection of Jane and David Davis
© 1998 Kate Rothko Prizel & Christopher Rothko /
Artists Rights Society (ARS), New York

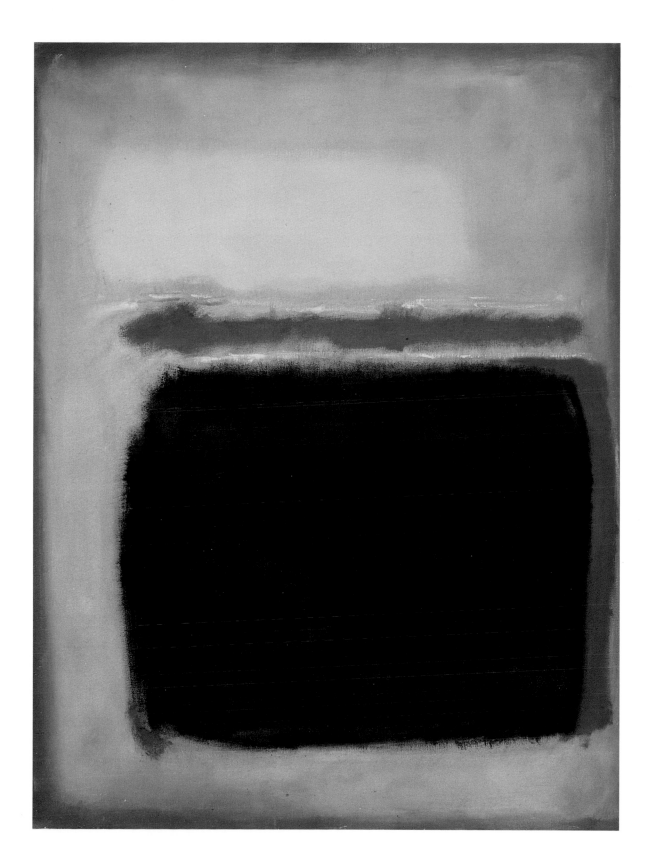

Alexander Calder

B. 1898, LAWNTON, PENNSYLVANIA; D. 1976, NEW YORK

Calder's parents were both artists, and he was encouraged to be creative from a very young age. Despite this background, he started out with a career as an engineer, receiving his degree from the Stevens Institute of Technology. However, after holding several jobs in the field, he decided to pursue a career as an artist. He attended the Art Students League in New York from 1923 to 1926, where he studied with Thomas Hart Benton and John Sloan. In the mid-1920s he spent weeks studying and sketching the circus, leading to his wire and wood constructions of circus figures and animals, with which he gave performances to colleagues and friends. In the early 1930s, Calder began to experiment with abstract imagery in his sculptures and give them movement. His Mobiles, as he called them, were composed of delicately balanced sheets of painted steel joined by swiveling lengths of wire. Playful and geometric in form, they range in size from small tabletop sculptures to massive chandelier-like structures in interior spaces. Calder also created Stabiles, which were large, brightly painted (usually orange) steel sculptures that were formally similar to his Mobiles but did not include kinetic elements.

Alexander Calder
Yellow Stalk with Stone
1953
Metal and stone
49½ × 40 in.
Collection of Jon and Mary Shirley
© 2006 Estate of Alexander Calder / Artists Rights Society (ARS), New York

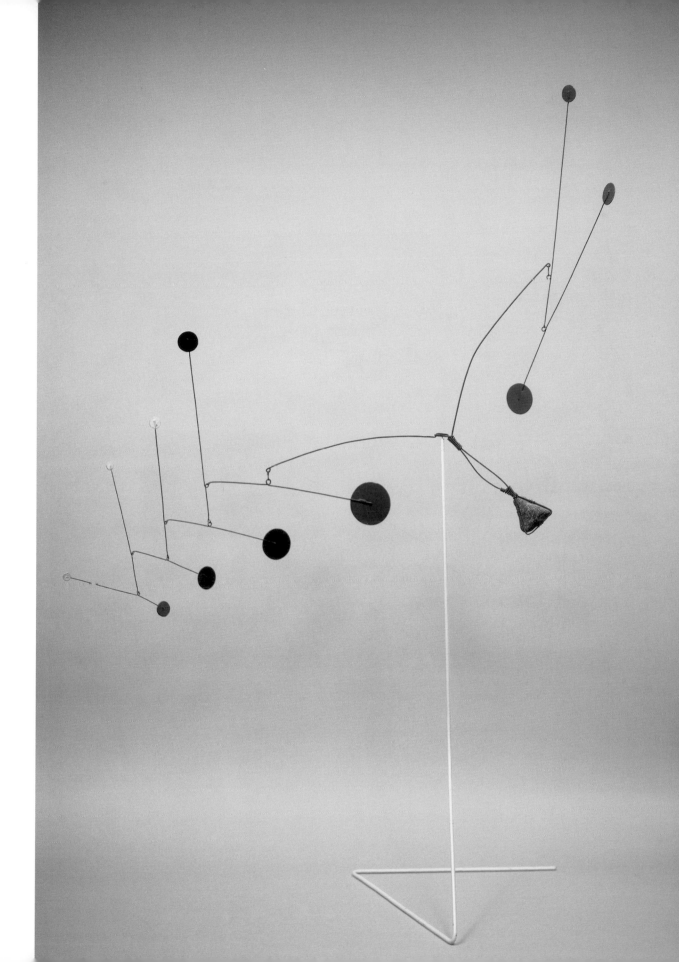

China joins forces with North Korea in the Korean War. Levittown is built on Long Island, and 17,400 homes go up for sale; development is nicknamed "Fertility Valley" and the "Rabbit Hutch" because of the rapid growth, with 40 houses a day be built at the peak of construction in 1949–50. 9% of U.S. homes have television sets. 1951 March: Estes Kefauver's Senate hear into organized crime (which began in May 1950) are broadcast live on national television. At the height of McCarthyism, Ju and Ethel Rosenberg are convicted of espionage against U.S.; they are executed by electric chair in June 1953. October: I L Lucy premieres on TV. 1952 August: Kemmon Wilson opens the first Holiday Inn in Memphis. September: Richard Nixon is "Checkers speech," portrays himself as a man of the people and saves his political career. October: The Adventures of O nd Harriet premieres on TV. November 1: First successful test of the hydrogen bomb is conducted near the Marshall Isla November: Dwight D. Eisenhower, the former Supreme Commander of the Allied Forces in Europe during World War I lected the 34th president over Democrat Adlai Stevenson. November 16: John Clellon Holmes uses the term "Beat Generat n his article "This Is the Beat Generation" in the New York Times Magazine. The B-52 bomber is developed. Sam Phillips of un Records in Memphis. He initially records Southern black musicians, but by the mid-1950s is promoting a fusion of black country music with recordings by Elvis Presley, Johnny Cash, and Carl Perkins, among others. First issue of MAD magazin published (the character of Alfred E. Neuman is introduced four years later). 1953 January: Arthur Miller's The Crucible, w uses the Salem witch trials as a metaphor for McCarthy's communist "witch hunts," is first performed on Broadway. February The Korean War truce is signed in Panmunjom. During two and a half years of fighting, more than 54,000 American soldiers nd 103,000 were wounded. March 5: Josef Stalin dies; in September, Nikita Khrushchev is named First Secretary of the US August 12: The USSR explodes the hydrogen bomb at the Semipalatinsk Test Site, Kazakhstan. The CIA, in a covert action, h o overthrow the Iranian government headed by Mohammad Mosaddeq and installs Shah Mohammad Reza Pahlavi in 1954. Fleming's Casino Royale, the first James Bond book, is published. The first issue of Playboy is published. 1954 May: French tr pull out of Vietnam. May: U.S. Supreme Court overturns "separate but equal" and rules that public school segregation is ill Bro...duction of...um...). June: Senator McCarthy is censured by the U.S. Senate. The CIA instig coup in Guatemala to stop the spread of communist...ated is published. M han one-h...mes have TVs (an estimated 26 million). Walt Disney and Lassie premiere on TV. 1955 January: egins sending foreign aid to the southern-based Republic of Vietnam. April: Jonas Salk's polio vaccine is introduced to the pu Bill Haley records "Rock Around the Clock." May 7: Rev. George Lee, an advocate for black voting rights, is murdered in Belz Mississippi. August 13: Lamar Smith, a World War II veteran and organizer of voter registration drives in the black commu s murdered in Brookhaven, Mississippi. August 28: Fourteen-year-old black Chicagoan Emmett Till, while visiting fami Mississippi, is kidnapped, brutally beaten, shot, and dumped in the Tallahatchie River for allegedly whistling at a white wor Two white men, J. W. Milam and Roy Bryant (the woman's husband), are arrested for the murder and acquitted by an all-white Sept 30: James Dean dies in a car crash at the age of 24. October: The Mickey Mouse Club and The Ed Sullivan Show premier TV. November: Allen Ginsberg gives his first reading of "Howl" (published in 1956) at the Six Gallery, San Francisco. Decemb NAACP member Rosa Parks refuses to give up her seat in the white section of a bus in Montgomery, Alabama. Decemb Dr. Martin Luther King Jr. begins a 54-week bus boycott in Montgomery (it will end on December 20, 1956, when the buses officially desegregated following a U.S. Supreme Court ruling). The Warsaw Pact Treaty, officially named the Treaty of Friends Co-operation, and Mutual Assistance, is organized as military support of Soviet interests in Central and Eastern Europ countries. Simon Rodia completes work on the Watts Towers in Los Angeles, which he began in 1921. Ray Kroc begins franch McDonald's hamburger stands. Daughters of Bilitis, the first lesbian organization in the U.S., is founded. Rebel without a Cause Blackboard Jungle signal a new market for teen movies. 1956 March: The Southern Manifesto, which opposes integration, is sig y congressmen from Southern states. March: Elvis records Heartbreak Hotel. It will become the first record to simultaneous number one on the pop, R&B, and country music charts. June: The Federal Aid Highway Act of 1956 authorizes constructio he interstate highway system. September: Grace Metalious's novel Peyton Place is published. November: Dwight D. Eisenho s reelected president. The Japanese American Citizens League successfully passes Proposition 13 in California, which ret and rights to Japan-born U.S. citizens. Rock 'n' roll takes hold as Elvis Presley ("Hound Dog" and "Don't Be Cruel"), L Richard ("Tutti Frutti"), Carl Perkins ("Blue Suede Shoes"), Chuck Berry ("Maybelline"), and Bo Diddley ("Bo Diddley") he charts. 1957 February: The Southern Christian Leadership Conference is founded by Martin Luther King Jr., Charle teele, and Fred Shuttlesworth; King is named its first president. It becomes a major force in organizing the civil rights mover nd advocating nonviolent civil disobedience. September: Leonard Bernstein's West Side Story, a musical version of Romeo uliet set in the context of New York street gangs, premieres on Broadway. September 24: Though the school board had v nanimously to begin desegregating the public schools, nine black students are blocked from entering Little Rock's Ce ligh School by Governor Orval Faubus. President Eisenhower sends federal troops to Little Rock to enforce desegreg

1955–60

EARLY CIVIL RIGHTS AND THE RISE OF YOUTH CULTURE

THE LATTER HALF OF THE 1950S, while still dominated by an emphasis on conformity and tradition, is marked by the birth of the civil rights movement, technological developments, and the emergence of dramatic new cultural forms. Although the McCarthy era had ended, the cold war continued to influence domestic politics, which remained fairly conservative. The baby boom and traditional family values continued to define American culture, with television shows such as *Leave It to Beaver* serving to perpetuate the myth of the idyllic nuclear family. However, new technologies were transforming American life; for example, the development of the interstate highway system in the latter half of the decade and the introduction of the first domestic passenger jet service offered unprecedented mobility. Aided in part by the new technology, American consumer culture entered a new era, with the opening of the first McDonald's franchises and the growth of suburbs around American cities. New cultural forms began to emerge, including rock 'n' roll and Elvis Presley's provocative alternative to traditional white, middle-class musical tastes. Beat poets and authors began publishing works, notably Allen Ginsberg's *Howl* and Jack Kerouac's *On the Road,* that presented a bold alternative to mainstream American culture and would inspire the counterculture of the next decade.

Internationally, as the cold war raged on, revolutionaries in the French colony of Algeria began a long battle for independence, foreshadowing a wave of challenges to Western imperial domination that would intensify in the 1960s. Domestically, African Americans began to mobilize as never before, inspired in part by Rosa Parks's courageous refusal to give up her seat on a bus in Montgomery, Alabama, in 1955. The civil rights movement would grow throughout the latter half of the 1950s, only to explode in the early 1960s, accompanied by protests across the American landscape.

—NVD

May 7: Rev. George Lee, an advocate for black voting rights, is murdered in Belzoni, Mississippi.

August 13: Lamar Smith, a World War II veteran and organizer of voter registration drives in the black community, is murdered in Brookhaven, Mississippi.

August 28: Fourteen-year-old black Chicagoan Emmett Till, while visiting family in Mississippi, 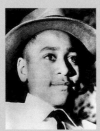 is kidnapped, brutally beaten, shot, and dumped in the Talla-hatchie River for allegedly whistling at a white woman. Two white men, J. W. Milam and Roy Bryant (the woman's husband), are arrested for the murder and acquitted by an all-white jury.

September 30: James Dean dies in a car crash at the age of 24.

March: The Southern Manifesto, which opposes integration, is signed by congressmen from Southern states.

Elvis records *Heartbreak Hotel*. It will become the first record to simultaneously be number one on the pop, R&B, and country music charts.

June: The Federal Aid Highway Act of 1956 authorizes construction of the interstate highway system.

September: Grace Metalious's novel *Peyton Place* is published.

November: Dwight D. Eisenhower is reelected president.

The Japanese American Citizens League success-fully passes Proposition 13 in California, which returns land rights to Japan-born U.S. citizens.

February: The Southern Christian Leadership Conference is founded by Martin Luther King Jr., Charles K. Steele, and Fred Shuttlesworth; King is named its first president. It becomes a major force in organizing the civil rights movement and advocating nonviolent civil disobedience.

September: Leonard Bernstein's *West Side Story*, a musical version of *Romeo and Juliet* set in the context of New York street gangs, premieres on Broadway.

September 24: Though 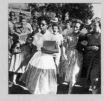 the school board had voted unanimously to begin desegregating the public schools, nine black students are blocked from entering Little Rock's Central High School by Governor Orval Faubus. President Eisenhower sends federal troops to Little Rock to enforce desegregation.

19**55** 19**56** 19**57**

November: Allen Ginsberg gives his first reading of "Howl" (published in 1956) at the Six Gallery, San Francisco.

December 1: NAACP member Rosa Parks refuses to give up her seat in the white section of a bus in Montgomery, Alabama.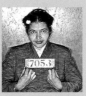

December 5: Dr. Martin Luther King Jr. begins a 54-week bus boycott in Montgomery (it will end on December 20, 1956, when the buses are officially desegregated following a U.S. Supreme Court ruling).

Rebel without a Cause and *Blackboard Jungle* signal a new market for teen movies.

Ray Kroc begins franchising McDonald's hamburger stands.

Rock 'n' roll takes hold as Elvis Presley ("Hound Dog" and "Don't Be Cruel"), Little Richard ("Tutti Frutti"), Carl Perkins ("Blue Suede Shoes"), Chuck Berry ("Maybelline"), and Bo Diddley ("Bo Diddley") top the charts.

October: The USSR launches *Sputnik*.

Leave It to Beaver premieres on TV.

Jack Kerouac's *On the Road* is published.

 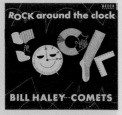 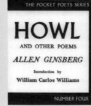

October: The National Aeronautics and Space Administration (NASA) is created.

December: The ultraconservative, anticommunist John Birch Society is founded in Indianapolis by Robert Welch.

December 10: The first domestic jet airline passenger service begins operations between New York City and Miami.

The film *The Defiant Ones* stars Sidney Poitier and Tony Curtis as escaped convicts—one black and one white—who are chained together and whose hostilities gradually evolve into friendship and respect.

The Kingston Trio, Ricky Nelson, and the Everly Brothers top the charts.

January 1: The forces of revolutionary leader Fidel Castro enter Havana; Castro becomes prime minister of the revolutionary government on February 16.

February 3: Buddy Holly, Ritchie Valens, and the Big Bopper (J. P. Richardson) die in a plane crash near Mason City, Iowa.

March: Lorraine Hansberry's *A Raisin in the Sun* opens on Broadway.

March 9: The Barbie doll is introduced to the world at the American Toy Fair in New York.

April 24: Mack Charles Parker, charged with raping a white woman, is abducted from his jail cell in Poplarville, Mississippi, by eight to ten white men who torture and shoot him, and then dump his body in the Pearl River.

April: The Student Non-violent Coordinating Committee (SNCC) is formed in Raleigh, North Carolina. It will later grow more radical under the leadership of Stokely Carmichael (1966–67).

July: Harper Lee's novel *To Kill a Mockingbird* is published.

December: U.S. Supreme Court rules that racial segregation in public transportation is illegal (*Boynton v. Virginia*).

Alfred Hitchcock's *Psycho* is released.

Brenda Lee, Elvis Presley, and the Everly Brothers top the charts.

19**58**

19**59**

19**60**

Fall: After almost two years of resistance to integration (including the closing of the high schools in Little Rock by Governor Faubus in 1958–59), Central High School reopens, effectively ending attempts to keep the school segregated.

October: *The Twilight Zone* premieres on TV.

November: The first African Americans are elected to local offices in North Carolina.

Alaska and Hawaii become the 49th and 50th states.

Frankie Avalon, Bobby Darin, and the Fleetwoods top the charts.

The Solomon R. Guggenheim Museum, designed by Frank Lloyd Wright, opens in New York.

Joan Mitchell
B. 1925, CHICAGO; D. 1992, FRANCE

Mitchell attended Smith College and the Art Institute of Chicago. During the summers, from 1943 to 1946, she resided in Mexico, where she was influenced by the works of José Clemente Orozco. She received her BFA from the Art Institute in 1947, and a fellowship allowed her to travel throughout Europe between 1948 and 1949. By 1949, Mitchell had begun to move away from her academic training toward a freer style inspired by Cézanne, van Gogh, and Kandinsky. Upon completing her MFA at the Art Institute in 1950, she moved to New York. It was at this time that she abandoned representation entirely and turned to painting abstractions based on her response to landscape. In New York, Mitchell came into contact with the Abstract Expressionist painters when she enrolled in Hans Hofmann's painting classes. She soon achieved prominence as one of the leading members of the "second generation" painters of the New York School. The works of Arshile Gorky and Willem de Kooning were important examples for her at that time, but perhaps most significant was her introduction to the paintings of Franz Kline. Mitchell quickly gained recognition and exhibited regularly throughout the 1950s, but she remained somewhat detached from the mainstream. She increased her distance from it when she moved to France, with Canadian-born French painter Jean Paul Riopelle, in 1955. In 1969, she took up residence in Vetheuil, where she lived and painted in a house connected to one in which Monet had once lived.

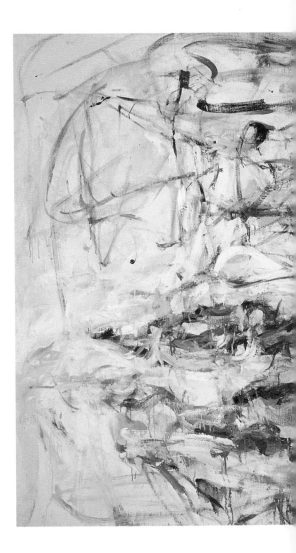

Joan Mitchell
The Sink
1956
Oil on canvas
55 × 133 in.
Collection of Jane and David Davis
© The Estate of Joan Mitchell

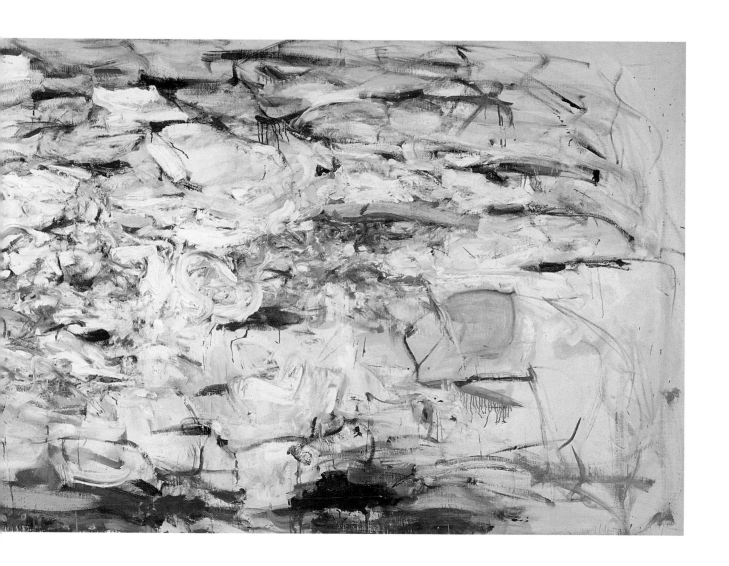

Hans Hofmann

B. 1880, WEISSENBURG, GERMANY; D. 1966,
NEW YORK

Hofmann was raised in Munich, where he studied at various art schools. From 1904 to 1914, on a stipend from a wealthy patron, he lived in Paris, where he met many of the leading figures of Fauvism, Cubism, and Orphism. He became close friends with Robert Delaunay, whom he credited with piquing his interest in color. In 1915, Hofmann set up an art school in Munich and taught there until 1930, when he immigrated to the United States. He taught for a summer at the University of California, Berkeley, before opening a school in New York in 1933. He established the Hans Hofmann School of Fine Arts in New York a year later. In 1934, he began a summer school at Provincetown, Massachusetts. In 1958, after gaining a huge reputation as a teacher, he stopped teaching and began painting full-time. He worked in many different styles, including the drip technique later made famous by Pollock, but is best known for his paintings featuring large, rectangular blocks of solid color on a fragmented background. Hofmann was enormously influential as both a teacher and a painter, and is often cited as one of the key figures in the development of Abstract Expressionism. He maintained that his paintings were all about the paint as a medium and, as such, each mark was loaded with meaning and purpose.

Hans Hofmann
The Bust
1957
Oil on canvas
48 × 36 in.
Collection of Herman and Faye Sarkowsky
© 2006 Estate of Hans Hofmann / Artists Rights
Society (ARS), New York

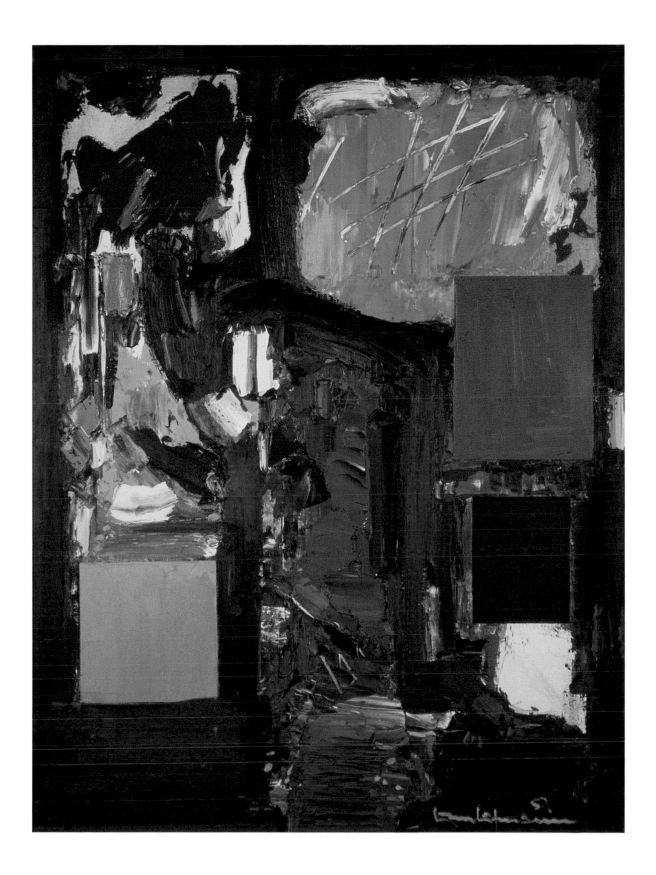

Jasper Johns

B. 1930, Augusta, Georgia; lives and works in New York and St. Martin

Raised in Allendale, South Carolina, Johns wanted to be an artist from an early age. After studying briefly at the University of South Carolina, Columbia, he moved in the early 1950s to New York, where he met John Cage, Merce Cunningham, and Robert Rauschenberg. Johns and Rauschenberg worked together at Bonwit Teller and Tiffany's creating window displays. Johns was exposed to many great modern art experiences in New York but was deeply moved after seeing Marcel Duchamp's *The Large Glass* in Philadelphia. Johns became very interested in Duchamp, especially in his disregard for traditional materials and his use of found objects. The writings of Austrian philosopher Ludwig Wittgenstein also had a great influence on Johns, who liked to toy with ideas of logic as well as the lack thereof. His early work combined a serious painting skill and mundane subject matter. Using simple but familiar subjects such as brightly colored flags, targets, and numbers,

he was able to lure the viewer in and then shift the emphasis from form to the process of painting itself. In 1958, while visiting Rauschenberg's studio, Leo Castelli saw some of Johns's work and offered him his first solo exhibition on the spot. Johns emerged as a powerful figure in the 1960s, helping to lead painting away from Abstract Expressionism back to more concrete forms. He also influenced the Pop movement by introducing everyday imagery into his art. Throughout his career Johns has collaborated with many artists, often across disciplines. In 1967, he met the poet Frank O'Hara and illustrated his book *In Memory of My Feelings;* he has designed sets for the Merce Cunningham Dance Company and served as its artistic director in 1967; and in the 1970s, he created a set of prints to accompany Samuel Beckett's text *Fizzles.* In recent decades, Johns has worked extensively in printmaking and has filled his art with highly personal autobiographical references.

Jasper Johns
Thermometer
1959
Oil on canvas
51¾ × 38½ in.
Collection of Virginia and Bagley Wright
Art © Jasper Johns / Licensed by VAGA, New York

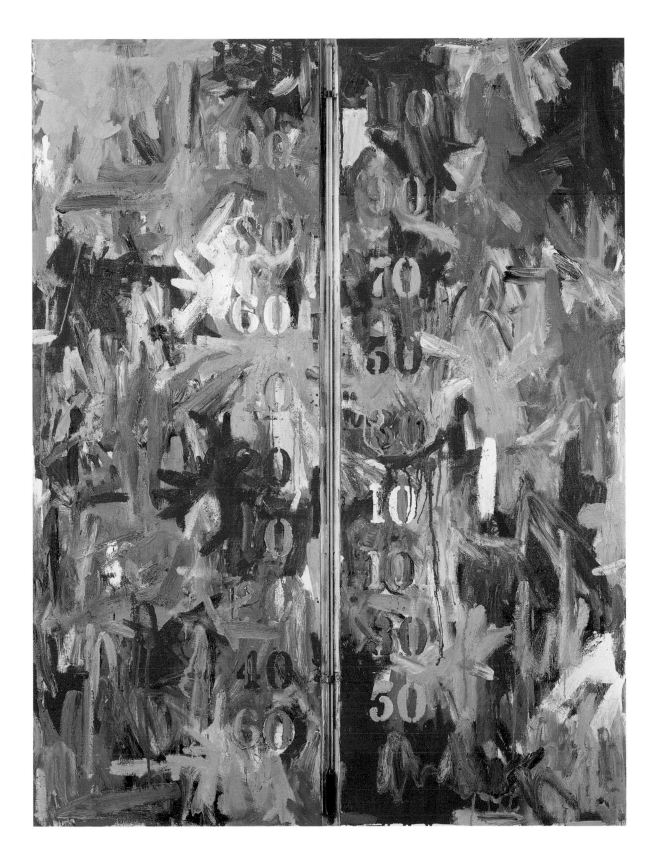

Robert Motherwell
**B. 1915, ABERDEEN, WASHINGTON; D. 1991,
CAPE COD, MASSACHUSETTS**

Motherwell was awarded a fellowship to Otis Art Institute, Los Angeles, at the age of eleven. He studied at the California School of Fine Arts in 1932, and received his BA in philosophy from Stanford University in 1936. After a brief enrollment in graduate school at Harvard University, studying philosophy, he decided to study abroad for a year and traveled to Europe in 1938. It was in Paris, in 1939, where he had his first solo exhibition, at the Raymond Duncan Gallery. In 1940, he returned to the United States and enrolled at Columbia University in New York, where he studied art history with Meyer Schapiro. Motherwell became a strong voice of his generation of artists, which included William Baziotes, Willem de Kooning, Jackson Pollock, and Hans Hofmann. His early works consisted of thinned washes of black paint that resembled shadows more than concrete forms and reflected the inspiration he drew from a visit to Mexico with his friend and fellow artist Roberto Matta. His mature style emerged in the 1950s and is characterized by massive canvases that captured the intimate quality of his smaller works and collages, which made the work more autobiographical by virtue of its subject matter. Motherwell was also an influential writer, serving as contributing editor for numerous art publications and writing many articles on art, but his most substantial contribution as an author/publisher came from the journal he produced with Ad Reinhardt in 1952, *Modern Artists in America.* Motherwell was married to Helen Frankenthaler from 1958 to 1971. Throughout his career, he taught and lectured while remaining a leading innovator in American painting and printmaking.

Robert Motherwell
The French Line
1960
Paper and paint collage
28⅜ × 22½ in.
Collection of Virginia and Bagley Wright
Art © Dedalus Foundation, Inc. / Licensed by VAGA,
New York

he leadership of Stokely Carmichael (1966–67). July: Harper Lee's novel *To Kill a Mockingbird* is published. December: upreme Court rules that racial segregation in public transportation is illegal (*Boynton v. Virginia*). Alfred Hitchcock's *Psych* eleased. Brenda Lee, Elvis Presley, and the Everly Brothers top the charts. 1960 May: The birth control pill is approved by 'DA. August: Muhammad Ali wins the gold medal in boxing at the Rome Olympics. October: The Kennedy-Nixon debates elevised nationally. November: John F. Kennedy is narrowly elected over Richard Nixon as the 35th president. Students f Democratic Society (SDS) is formed. 87% of U.S. homes have television sets. 1961 March: The Peace Corps is created by Presid Kennedy. April 17: A U.S.-backed group of 1,300 Cuban exiles lands at the Bay of Pigs, in Cuba, in an unsuccessful attemp verthrow Fidel Castro. May: The Congress of Racial Equality (CORE) sends student volunteers on bus trips throughout outh, which are labeled Freedom Rides. One bus is stoned and another is firebombed. These activities would eventually lea he outlawing of segregation in interstate bus travel. August: East Germany erects the Berlin Wall. President Kennedy establi he President's Commission on the Status of Women, with Eleanor Roosevelt as chair. Motown Records is founded in Detro Berry Gordy. John Griffin's *Black Like Me*, the story of a white man who passes as black, is published. Comedian Lenny Bru rrested on obscenity charges in San Francisco. 1962 February: John Glenn becomes the first astronaut to orbit the earth. A Bob Dylan first performs "Blowin' in the Wind" (released 1963). June: At a meeting of SDS in Port Huron, Michigan, stud write the "Port Huron Statement," a manifesto that reflects the disillusionment of young people at the time. August 5: Mar Monroe dies of a drug overdose. September: James Meredith is denied admission to the University of Mississippi as the first b tudent. Violence surrounding the incident leads President Kennedy to send 5,000 federal troops. October 16–28: Cuban Mi Crisis: The threat of Soviet missiles being installed in Cuba leads the U.S. to the brink of war; these 13 days are regarded as ne moment when the cold war came close to escalating to nuclear war. Cesar Chavez and others found the United Farm Wor nion in towns throughout California. Although identified as a Latino organization, the union will go on to achieve significant g or all farmworkers through successful boycotts of agricultural products. The drug thalidomide is removed from the market

1960–65

once...General...claims...by Checker tops the charts with " Twist." John...begins hosting *The Tonight Show*...horing the *CBS Evening News*. 1963 A Sidney Poitier wins an Oscar for best actor *...ies of the Field*. April 16: Martin Luther King Jr. is arrested during antisegreg rotests in Birmingham, Alabama. He writes his seminal "Letter from Birmingham Jail," arguing that individuals have a m uty to disobey unjust laws. June 12: The NAACP's Mississippi field secretary, 37-year-old Medgar Evers, is assassinated out his home in Jackson. Byron De La Beckwith will stand trial twice in the 1960s; both trials ended in a hung (all-white) jury. T ecades later, in 1994, he is convicted of murder. August 28: Martin Luther King Jr. makes his "I Have a Dream" speech a March on Washington. September 15: A racially motivated bombing of the 16th Street Baptist Church in Birmingham kills girls: Denise McNair, Cynthia Wesley, Carole Robertson, and Addie Mae Collins. November 22: President John F. Kenne ssassinated in Dallas; Lyndon B. Johnson becomes president. James Baldwin's *The Fire Next Time* is published. Betty Frie *The Feminine Mystique* is published. 1964 January: The 24th Amendment abolishes poll taxes, which had been instituted i Southern states after Reconstruction as a way of making it difficult for poor blacks to vote. February: The Beatles perform on *Ed Sullivan Show*. Summer: The Council of Federated Organizations (COFO) launches a massive effort to register black vo luring what will become known as Freedom Summer. June 21: Civil Rights workers Andrew Goodman, Michael Schwerner, James Chaney are murdered in Mississippi. August: The Gulf of Tonkin Resolution authorizes the bombing of Vietnam by roops. November: Lyndon B. Johnson is elected the 36th president. December: Student Mario Savio organizes Free Sp Movement protests at UC Berkeley; 796 people are arrested. December: Martin Luther King Jr. is awarded the Nobel P Prize. President Johnson signs the Civil Rights Act of 1964, the most sweeping civil rights legislation since Reconstructio rohibits discrimination of all kinds based on race, color, religion, or national origin. VISTA (Volunteers in Service to Ame s created as part of the Johnson administration's "war on poverty" legislation. The Beatles, the Supremes, and Roy Orbiso he charts. 1965 February 21: Malcolm X, black nationalist and founder of the Organization of Afro-American Unity, is sh leath in New York City. February: Operation Rolling Thunder begins large-scale bombing of North Vietnam. March: The U.S. combat troops are sent to Vietnam (by July, troops will increase from 75,000 to 125,000). March: The first anti–Viet War teach-in is held, at the University of Michigan, Ann Arbor. March 7: Voting rights demonstrations in Selma, Alabama stopped by police blockade; one marcher is killed, others are severely injured, and more than 2,000 are arrested. July: The E Employment Opportunity Commission begins its work. July 25: Bob Dylan creates controversy at the Newport Folk Festiva laying electrified "folk rock." August 11–16: The Watts riots in Los Angeles leave 34 dead and cause $200 million in prop damage. September: President Johnson issues Executive Order 11246, which enforces affirmative action in all aspects of h nd employment. *The Autobiography of Malcolm X* is published. September: United Farm Workers strike against California g rowers. Herbert Marcuse's *Culture and Society* is published. The Rolling Stones release "Satisfaction." 1966 January: U.S.

AMERICA EXPERIENCED A NUMBER of dramatic social developments in the early 1960s. The country's political scene took a turn to the left with the election of John F. Kennedy as president in 1960 and the emergence of several powerful social movements. Following the famous antisegregation lunch counter sit-in in Greensboro, North Carolina, in February 1960, nonviolent acts of protest spread throughout the American South, and the fight for African American civil rights became a large-scale social movement. The decade also saw the baby boom generation come of age and enter college, leading to an expansion of the nation's system of higher education. Fueled in part by a feeling of political efficacy inspired by the sheer size of their own cohort, American college students began engaging in political activism in numbers not seen before nor since. The economic prosperity of the decade filled Americans with a sense of possibility. As the United States launched its first spacecrafts, the unbounded potential of space travel captured the country's imagination.

Internationally, hostilities between the East and the West continued. In 1961, East Germany erected the Berlin Wall, which stood as not only a physical but also a symbolic barrier between communist Eastern Europe and the capitalist democracies of the West. The United States managed to avoid one war during the Cuban Missile Crisis in 1962, but by the middle of the decade found itself engaged in another, in Vietnam, sparking antiwar protests across the country. Ongoing efforts by the civil rights movement and groups such as Martin Luther King Jr.'s Southern Christian Leadership Conference led to some important victories in the mid-1960s, including the passage of the Civil Rights and Voting Rights Acts. However, African Americans grew increasingly frustrated with the intransigent problems of urban poverty and racial inequality. The violence of the Watts riots in Los Angeles in August 1965 was, unfortunately, a harbinger of things to come.

—NVD

February: Four black students from North Carolina Agricultural and Technical College stage a sit-in at a segregated Woolworth's lunch counter in Greensboro. The event triggers similar nonviolent protests throughout the South.

May: The birth control pill is approved by the FDA.

August: Muhammad Ali wins the gold medal in boxing at the Rome Olympics.

October: The Kennedy-Nixon debates are televised nationally.

March: The Peace Corps is created by President Kennedy.

April 17: A U.S.-backed group of 1,300 Cuban exiles lands at the Bay of Pigs, in Cuba, in an unsuccessful attempt to overthrow Fidel Castro.

May: The Congress of Racial Equality (CORE) sends student volunteers on bus trips throughout the South, which are labeled Freedom Rides. One bus is stoned and another is firebombed. These activities would eventually lead to the outlawing of segregation in interstate bus travel.

August: East Germany erects the Berlin Wall.

President Kennedy establishes the President's Commission on the Status of Women, with Eleanor Roosevelt as chair.

February: John Glenn becomes the first astronaut to orbit the earth.

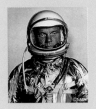

April: Bob Dylan first performs "Blowin' in the Wind" (released 1963).

June: At a meeting of SDS in Port Huron, Michigan, students write the "Port Huron Statement," a manifesto that reflects the disillusionment of young people at the time.

August 5: Marilyn Monroe dies of a drug overdose.

September: James Meredith is denied admission to the University of Mississippi as the first black student. Violence surrounding the incident leads President Kennedy to send 5,000 federal troops.

19**60**

19**61**

19**62**

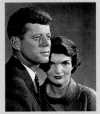

November: John F. Kennedy is narrowly elected over Richard Nixon as the 35th president.

Students for a Democratic Society (SDS) is formed.

87% of U.S. homes have television sets.

Motown Records is founded in Detroit by Berry Gordy.

John Griffin's *Black Like Me,* the story of a white man who passes as black, is published.

Comedian Lenny Bruce is arrested on obscenity charges in San Francisco.

October 16–28: Cuban Missile Crisis: The threat of Soviet missiles being installed in Cuba leads the U.S. to the brink of war; these 13 days are regarded as the one moment when the cold war came close to escalating to nuclear war.

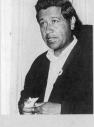

Cesar Chavez and others found the United Farm Workers union in towns throughout California. Although identified as a Latino organization, the union will go on to achieve significant gains for all farmworkers through successful boycotts of agricultural products.

The drug thalidomide is removed from the market over concerns about birth defects.

General Motors claims 51% of the American car market.

Chubby Checker tops the charts with "The Twist."

Johnny Carson begins hosting *The Tonight Show* and Walter Cronkite begins anchoring the *CBS Evening News.*

April: Sidney Poitier wins an Oscar for best actor for *Lilies of the Field*.

April 16: Martin Luther King Jr. is arrested during antisegregation protests in Birmingham, Alabama. He writes his seminal "Letter from Birmingham Jail," arguing that individuals have a moral duty to disobey unjust laws.

June 12: The NAACP's Mississippi field secretary, 37-year-old Medgar Evers, is assassinated outside his home in Jackson. Byron De La Beckwith will stand trial twice in the 1960s; both trials end in a hung (all-white) jury. Three decades later, in 1994, he is convicted of murder.

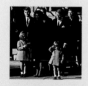
August 28: Martin Luther King Jr. makes his "I Have a Dream" speech at the March on Washington.

January: The 24th Amendment abolishes poll taxes, which had been instituted in 11 Southern states after Reconstruction as a way of making it difficult for poor blacks to vote.

February: The Beatles perform on the *Ed Sullivan Show*.

April: The New York World's Fair opens.

Summer: The Council of Federated Organizations (COFO) launches a massive effort to register black voters during what will become known as Freedom Summer.

June 21: Civil rights workers Andrew Goodman, Michael Schwerner, and James Chaney are murdered in Mississippi.

August: The Gulf of Tonkin Resolution authorizes the bombing of Vietnam by U.S. troops.

November: Lyndon B. Johnson is elected the 36th president.

February 21: Malcolm X, black nationalist and founder of the Organization of Afro-American Unity, is shot to death in New York City.

March 7: Voting rights demonstrations in Selma, Alabama, are stopped by police blockade; one marcher is killed, others are severely injured, and more than 2,000 are arrested.

July: The Equal Employment Opportunity Commission begins its work.

August 11–16: The Watts riots in Los Angeles leave 34 dead and cause $200 million in property damage.

September: President Johnson issues Executive Order 11246, which enforces affirmative action in all aspects of hiring and employment.

19**63**

19**64**

19**65**

September 15: A racially motivated bombing of the 16th Street Baptist Church in Birmingham kills four girls: Denise McNair, Cynthia Wesley, Carole Robertson, and Addie Mae Collins.
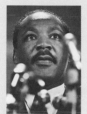

November 22: President John F. Kennedy is assassinated in Dallas; Lyndon B. Johnson becomes president.

James Baldwin's *The Fire Next Time* is published.

Betty Friedan's *The Feminine Mystique* is published.

December: Student Mario Savio organizes Free Speech Movement protests at UC Berkeley; 796 people are arrested.

Martin Luther King Jr. is awarded the Nobel Peace Prize.

President Johnson signs the Civil Rights Act of 1964, the most sweeping civil rights legislation since Reconstruction. It prohibits discrimination of all kinds based on race, color, religion, or national origin.

VISTA (Volunteers in Service to America) is created as part of the Johnson administration's "war on poverty" legislation.

The Beatles, the Supremes, and Roy Orbison top the charts.

The Autobiography of Malcolm X is published.

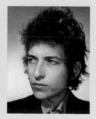

Morris Louis
B. 1912, BALTIMORE, MARYLAND; D. 1962, WASHINGTON, D.C.

Morris Louis won a state competition at the age of fifteen that provided him with a four-year scholarship to the Maryland Institute of Fine and Applied Arts, from which he received his degree in 1933. He moved to New York City in 1936 and became good friends with Leonard Bocour, who developed and manufactured paint and would later create a special formula of his acrylic-resin Magna paints exclusively for Louis and Kenneth Noland. Louis moved to Washington, D.C., in 1952 to teach at the Washington Workshop Center of the Arts. While visiting Helen Frankenthaler's studio with Noland in 1953, Louis was greatly impressed by her stain painting technique and, after returning to Washington, began to experiment with ways of pouring Magna paint on unprimed canvases. During that visit to New York, he also met critic Clement Greenberg, who saw the potential in Louis and included him in an exhibition of new talent at the Kootz Gallery. Greenberg remained a strong supporter of Louis's work throughout his career. Louis was a key figure in the development of Post-Painterly Abstraction, using pure color and instilling a certain calm in his "pours," compared to the aggression of Action painting. He was able to control the pour of his paints, allowing the color to bleed and run as it dried on the canvases to achieve a subdued physical imposition on the outcome of his paintings.

Morris Louis
Untitled (Stripe #21)
1961–62
Acrylic on canvas
90 × 17¾ in.
Collection of Jane and David Davis
© 1962 Morris Louis

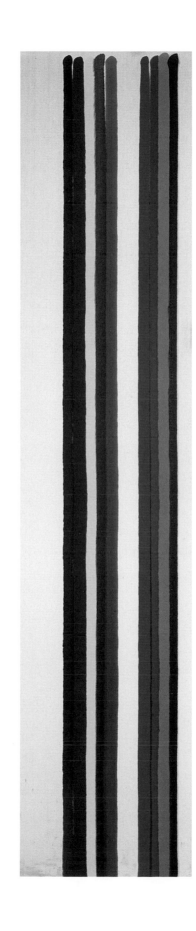

Frank Stella
B. 1936, MALDEN, MASSACHUSETTS; LIVES AND WORKS IN NEW YORK

Stella went to high school at the Phillips Academy in Andover, Massachusetts, then attended Princeton University, where he majored in history. His interest in modern art was piqued by visits to New York art galleries, which would prove to be an influence on his artistic development. Stella moved to New York in 1958 after receiving his degree. In his early works, he eliminated any reference to depth or illusionistic space, thereby intensifying the flatness of the surface. He chose square canvases as opposed to rectangular ones to avoid traditional compositional constraints. During the 1970s, Stella introduced relief into his art, which he came to call "maximalist" painting for its sculptural elements. These paintings, which included cutout shapes in relief, were almost antithetical to his earlier paintings, which followed the Minimalist tenet of applying paint impersonally to a flat surface. After introducing wood and other materials to the works created in high relief, he began to use aluminum as the primary support for his paintings. Through the 1970s and 1980s, Stella's works became more elaborate and energetic, with curving forms and Day-Glo colors, which made them seem almost baroque compared to his earlier Minimalist works.

Frank Stella
Rye Beach
1963
Alkyd on canvas
30⅜ × 60½ in.
Collection of Herman and Faye Sarkowsky
© 2006 Frank Stella / Artists Rights Society (ARS), New York

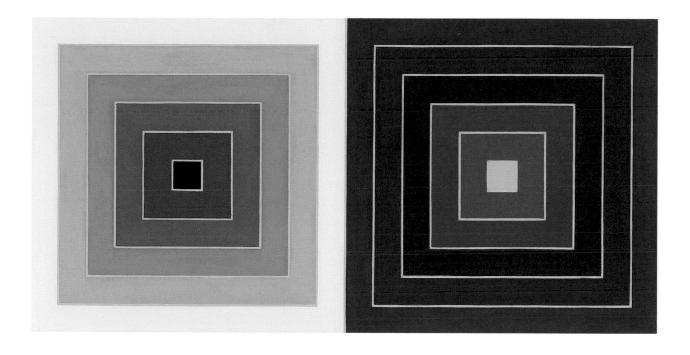

Robert Rauschenberg

B. 1925, PORT ARTHUR, TEXAS; LIVES AND WORKS IN CAPTIVA, FLORIDA

Rauschenberg did not pursue his interest in art until his mid-twenties. While serving in the U.S. Navy, he discovered that he had an affinity for artistic representations of people and mundane objects. Soon after leaving the military, he studied briefly in Paris but was uninspired by the European art scene. He moved to North Carolina and attended Black Mountain College, where he studied under Josef Albers and Buckminster Fuller. It was there that he, dancer Merce Cunningham, composer John Cage, and fellow artist Jasper Johns began a revolution of interdisciplinary creativity. He took these ideas to New York City in 1949, and in the fertile chaos of the city began to use everyday objects and materials in place of traditional media while still demonstrating proficiency in formalist painting. In 1953, he completed a series of black paintings, using newspaper as the ground, and began work on sculptures created from wood, stones, and other found materials. He also made paintings that incorporated tissue paper, dirt, or gold leaf. These were followed by more conceptually oriented works such as *Automobile Tire Print* and *Erased de Kooning Drawing* (both 1953). The latter is considered by some to represent a notable shift or bridge from Abstract Expressionism to the conceptual agenda that would mark subsequent decades. Rauschenberg's signature work took the form of "combines," the term he used to describe his collages, or combinations, of two- or three-dimensional found objects and images. In 1963, he had a retrospective exhibition at the Jewish Museum, making him one of the youngest artists to receive a retrospective at a major museum. Through the 1960s and 1970s, he continued to experiment with a variety of ways, including performance and film, to engage the viewer as an active participant in the work. He has also been an innovator in printmaking, exploring many different media and techniques, including the layering of photo transfers.

Robert Rauschenberg
Manuscript
1963
Oil on canvas
84 × 60 in.
Collection of Virginia and Bagley Wright
Art © Robert Rauschenberg / Licensed by VAGA, New York

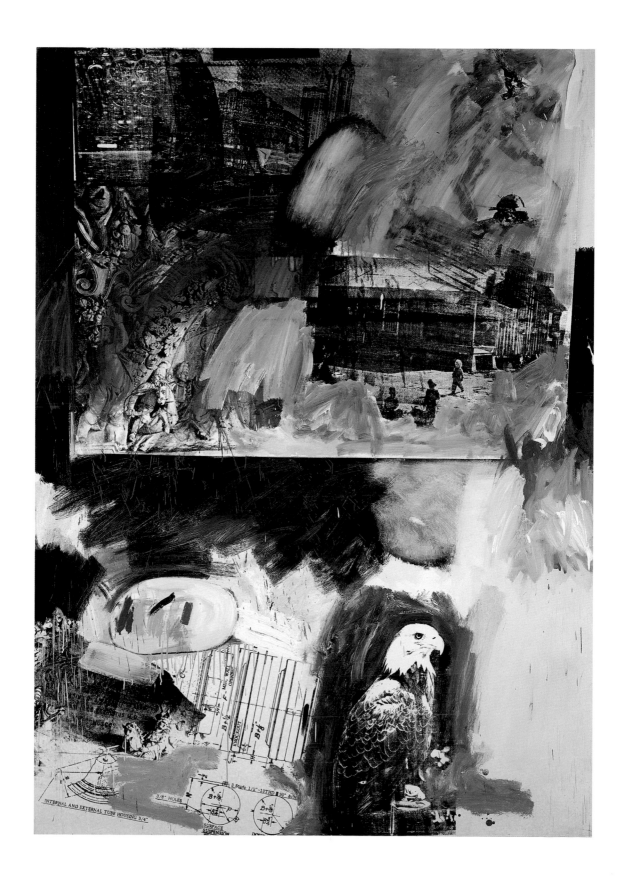

Kenneth Noland

B. 1924, ASHEVILLE, NORTH CAROLINA; LIVES AND WORKS IN PORT CLYDE, MAINE

Noland attended Black Mountain College in North Carolina between 1946 and 1948 and studied with Ossip Zadkine in Paris from 1948 to 1949. While teaching at the Washington Workshop Center of the Arts, he became identified with a group of artists that included Morris Louis. He became friends with Leonard Bocour, the inventor of Magna acrylic resin paint, who made a liquid formula specifically for Noland and Louis. Both artists, along with Helen Frankenthaler and other second-generation artists of the New York School, were championed by the critic Clement Greenberg, who coined the term Post-Painterly Abstraction to describe their Color Field work. While maintaining an affinity for pure color, Noland moved away from the nonobjective painting of Louis and others as his work became more deliberately controlled and even "representational" or emblematic. His use of stripes, chevrons, and target shapes qualifies his paintings as a bridge between Post-Painterly Abstraction and the more geometric-minded works of the Op and Minimalist artists.

Kenneth Noland
And Again
1964
Acrylic resin on unprimed canvas
69½ × 69½ in.
Collection of Virginia and Bagley Wright
Art © Kenneth Noland / Licensed by VAGA, New York

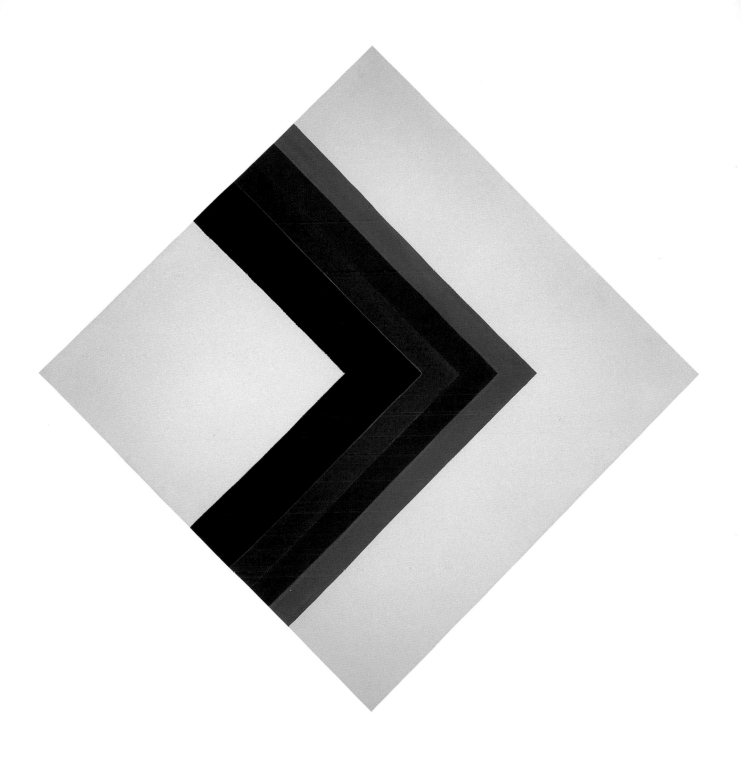

Roy Lichtenstein
B. 1923, NEW YORK; D. 1997, NEW YORK

As a teenager in New York, Lichtenstein took art classes at Parsons School of Design and painting classes from Reginald Marsh at the Art Students League. In 1940, he enrolled at Ohio State to pursue a fine arts degree. Drafted into the U.S. Army in 1943, he returned to Ohio State after he was discharged in 1946 to complete his master's degree. He married, had children, and spent several years teaching in Columbus and Cleveland while continuing to pursue his art career. In 1957, he took a teaching position at the State University of New York at Oswego. There he began the leap from whimsical paintings depicting moments from American history to a loose, expressionistic style that included cartoon figures such as Mickey Mouse and Donald Duck. In 1960, he took a teaching position at Rutgers University in New Jersey. The move brought him closer to New York and introduced him to artists Allan Kaprow, Claes Oldenburg, Lucas Samaras, and others. In 1961, Lichtenstein created *Look Mickey* and *Popeye,* the first paintings in which he directly appropriated cartoon panels from comic strips and began his trademark use of Benday dots. Curator Paul Schimmel has identified these paintings, along with Warhol's from the same period, as constituting the "first true Pop art." Through his affiliation with the Leo Castelli Gallery, Lichtenstein was introduced to Robert Rauschenberg, Jasper Johns, Warhol, and Tom Wesselmann. In 1962, he began making works based on war comics and others that borrowed from Cézanne and Mondrian. By 1964, he was one of Pop's most recognizable image makers and was even featured in a *Life* magazine article entitled "Is He the Worst Artist in the U.S.?" which described him as the cause célèbre of the art world. The following year, he made *Explosion* sculptures, his first three-dimensional works. For the rest of his career, he continued to experiment with sculpture and painting and also became a master of printmaking processes while staying true to his unique style and vision.

Roy Lichtenstein
Standing Explosion Sculpture
1965
Enamel on steel
26 × 25 × 27 in.
Collection of Richard Weisman
© Estate of Roy Lichtenstein

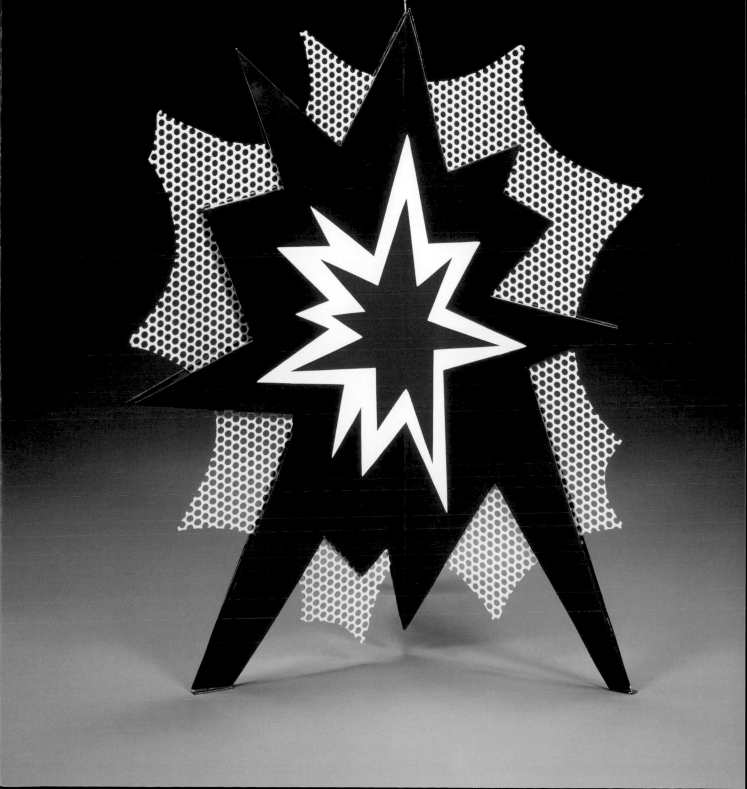

Baldwin's *The Fire Next Time* is published. Betty Friedan's *The Feminine Mystique* is published. 1964 January: The 2 amendment abolishes poll taxes, which had been instituted in 11 Southern states after Reconstruction as a way of makin difficult for poor blacks to vote. February: The Beatles perform on the *Ed Sullivan Show*. Summer: The Council of Federa Organizations (COFO) launches a massive effort to register black voters during what will become known as Freedom Sumr June 21: Civil Rights workers Andrew Goodman, Michael Schwerner, and James Chaney are murdered in Mississippi. Aug The Gulf of Tonkin Resolution authorizes the bombing of Vietnam by U.S. troops. November: Lyndon B. Johnson is elec ne 36th president. December: Student Mario Savio organizes Free Speech Movement protests at UC Berkeley; 796 people rrested. December: Martin Luther King Jr. is awarded the Nobel Peace Prize. President Johnson signs the Civil Rights Ac 964, the most sweeping civil rights legislation since Reconstruction. It prohibits discrimination of all kinds based on race, co eligion, or national origin. VISTA (Volunteers in Service to America) is created as part of the Johnson administration's "war overty" legislation. The Beatles, the Supremes, and Roy Orbison top the charts. 1965 February 21: Malcolm X, black nation: nd founder of the Organization of Afro-American Unity, is shot to death in New York City. February: Operation Rolling Thun egins large-scale bombing of North Vietnam. March: The first U.S. combat troops are sent to Vietnam (by July, troops will incre rom 75,000 to 125,000). March: The first anti–Vietnam War teach-in is held, at the University of Michigan, Ann Arbor. Marc oting rights demonstrations in Selma, Alabama, are stopped by police blockade; one marcher is killed, others are severely inju nd more than 2,000 are arrested. July: The Equal Employment Opportunity Commission begins its work. July 25: Bob Dy reates controversy at the Newport Folk Festival by playing electrified "folk rock." August 11–16: The Watts riots in Los Ang eave 34 dead and cause $200 million in property damage. September: President Johnson issues Executive Order 11246, wl nforces affirmative action in all aspects of hiring and employment. *The Autobiography of Malcolm X* is published. Septeml United Farm Workers strike against California grape growers. Herbert Marcuse's *Culture and Society* is published. The Rol tones release "Satisfaction." 1966 January: U.S. troops in Vietnam exceed 184,000. March: International Days of Protest aga e the largest gathering 25,000 people in New York City. June: The National Organization for Wor NOW) is founded. October: The Black Panthers are founded by Bobby Seale and Huey P. New November: Ronald Reagan is elected governor of California and vows to crack down on antiwar protesters. December: *Tin* Man of the Year" award goes to the "Younger Generation." The Senate Foreign Relations Committee's hearings on Vietn haired by William Fulbright, are broadcast nationally on TV. First convictions are brought against protesters for burning th raft cards. LSD is declared an illegal substance. Masters and Johnson's *Human Sexual Response* is published. Simon & Garfun he Mamas and the Papas, and the Rolling Stones top the charts. 1967 January: Counterculture leaders organize a "human be n San Francisco's Golden Gate Park to promote peace, happiness, and love. April: *In the Heat of the Night* wins the Oscar est picture. April 19: Stokely Carmichael coins the phrase "black power" in a speech in Seattle. June: The Beatles' *Sgt. Pepp onely Hearts Club Band* is released in the U.S. June: Muhammad Ali is sentenced to five years in prison for refusing mili ervice. June: The U.S. Supreme Court rules that prohibiting interracial marriage is unconstitutional (*Loving v. Virginia*). J 6–18: The Monterey Pop Festival gathers the counterculture together, setting off the "Summer of Love," which is centere ne Haight-Ashbury district of San Francisco. July 12–17: Race riots in Newark leave 26 dead and 1,500 injured. A week la uly 23–28), riots in Detroit leave 43 dead, 2,000 injured, and 5,000 homeless. October: Thurgood Marshall becomes the I frican American Supreme Court justice. October: Antiwar demonstrators march on the Pentagon. November: Jann Wen ublishes the first issue of *Rolling Stone* magazine in San Francisco. Marshall McLuhan and Quentin Fiore's *The Medium ne Massage* is published. Aretha Franklin, the Doors, Janis Joplin, and Jimi Hendrix top the charts. 1968 January: *Rowar Martin's Laugh-In* premieres on TV. January 31: The Tet Offensive is launched by the Viet Cong. March 31: With Vietnam poli ecoming increasingly unpopular, President Johnson makes a surprise announcement that he will not run for reelection. Apr Martin Luther King Jr. is shot and killed in Memphis by James Earl Ray. April: Title VIII of the Civil Rights Act of 1968 (air Housing Act) prohibits racial discrimination in housing. May 12–June 19: Poor People's March on Washington takes pla ne 6: Robert F. Kennedy is shot and killed by Sirhan Sirhan in Los Angeles while campaigning for the Democratic presiden omination. August 26–28: Antiwar demonstrators clash with police at the Democratic National Convention in Chicago. Octo nerican medalists Tommy Smith and John Carlos are expelled from the Mexico City Olympics after giving the black-power sa uring the award ceremony. November: Richard M. Nixon is narrowly elected over Hubert Humphrey as the 37th preside ldridge Cleaver's *Soul on Ice* is published. Tom Wolfe's *The Electric Kool-Aid Acid Test*, a narrative of Ken Kesey's Me ranksters, is published. *Zap Comix* is first published in San Francisco. 1969 April: The number of U.S. troops in Vietnam reac 43,000. May 15–30: People's Park riots in Berkeley. June 27: The Stonewall riots in New York mark the rise of the gay libera ovement. July 21: Neil Armstrong walks on the moon. August 9: Members of the "Manson family" murder Sharon Tate ur friends in Los Angeles. August 15–17: The Woodstock Music and Art Fair gathers 450,000 people in Bethel, New Yor

1965–70

THE LATE 1960S WERE an unusually turbulent period in American history, marked by widespread political unrest. American economic prosperity continued steadily, fueling investment in technology and social programs. The space program made remarkable advancements, reaching its zenith in 1969, when Neil Armstrong walked on the moon. However, in spite of these positive developments, the nation's citizens became increasingly divided politically.

As the United States increased its involvement in the Vietnam War, antiwar protests gained in size and frequency. After achieving success in desegregating the South, the civil rights movement turned its attention to urban poverty, and between 1965 and 1970, hundreds of riots took place in American cities. The spread of violent unrest across the country scared many who had previously supported the protest movements and helped Richard Nixon, running on a law-and-order platform, win the presidency in 1968. In the latter years of the decade, increasing frustration with the slow pace of social change led to conflict within the civil rights and antiwar movements, and radical groups such as the Weather Underground and the Black Panthers abandoned nonviolent protest tactics. Internationally, the period was also marked by political unrest: many former European colonies began to seek independence,

and college students in Europe, following the lead of their American peers, mobilized, sometimes violently, for social change.

A vibrant counterculture, which had begun stirring in the previous decade, blossomed alongside the protest movements. Young people wishing to explore alternatives to mainstream American culture participated in unique events such as the Summer of Love and the Woodstock music festival. However, not all Americans shared the enthusiasm of the young revolutionaries. Many Americans disapproved of the counterculture, and some formed countermovements to support the war, accusing the antiwar protesters of being unpatriotic. Others resisted the changes brought about by the civil rights movement, sometimes through violent acts such as church bombings and attacks on civil rights workers. As the decade ended, sobering events such as the assassination of Martin Luther King Jr. and the National Guard's shooting of college students at Kent State dampened student enthusiasm for protest. However, inspired by the successes of the civil rights movement, other marginalized groups, including women, gays and lesbians, Native Americans, and Chicanos, began to mobilize into social movements that continue to shape our culture to this day.

—NVD

February: Operation Rolling Thunder begins large-scale bombing of North Vietnam.

March: The first U.S. combat troops are sent to Vietnam (by July, troops will increase from 75,000 to 125,000).

The first anti–Vietnam War teach-in is held, at the University of Michigan, Ann Arbor.

July 25: Bob Dylan creates controversy at the Newport Folk Festival by playing electrified "folk rock."

January: U.S. troops in Vietnam exceed 184,000.

March: International Days of Protest against the Vietnam War; the largest gathering draws 25,000 people in New York City.

June: The National Organization for Women (NOW) is founded.

October: The Black Panthers are founded in Oakland, California, by Bobby Seale and Huey P. Newton.

November: Ronald Reagan is elected governor of California and vows to crack down on antiwar protesters.

December: *Time*'s "Man of the Year" award goes to the "Younger Generation."

January: Counterculture leaders organize a "human be-in" in San Francisco's Golden Gate Park to promote peace, happiness, and love.

April: *In the Heat of the Night* wins the Oscar for best picture.

April 19: Stokely Carmichael coins the phrase "black power" in a speech in Seattle.

June: The Beatles' *Sgt. Pepper's Lonely Hearts Club Band* is released in the U.S.

Muhammad Ali is sentenced to five years in prison for refusing military service.

The U.S. Supreme Court rules that prohibiting interracial marriage is unconstitutional (*Loving v. Virginia*).

19**65**

19**66**

19**67**

September: United Farm Workers strike against California grape growers.

Herbert Marcuse's *Culture and Society* is published.

The Rolling Stones release "Satisfaction."

The Senate Foreign Relations Committee's hearings on Vietnam, chaired by William Fulbright, are broadcast nationally on TV.

First convictions are brought against protesters for burning their draft cards.

LSD is declared an illegal substance.

Masters and Johnson's *Human Sexual Response* is published.

Simon & Garfunkel, the Mamas and the Papas, and the Rolling Stones top the charts.

June 16–18: The Monterey Pop Festival gathers the counterculture together, setting off the "Summer of Love," which is centered in the Haight-Ashbury district of San Francisco.

July 12–17: Race riots in Newark leave 26 dead and 1,500 injured. A week later (July 23–28), riots in Detroit leave 43 dead, 2,000 injured, and 5,000 homeless.

October: Thurgood Marshall becomes the first African American Supreme Court justice.

Antiwar demonstrators march on the Pentagon.

November: Jann Wenner publishes the first issue of *Rolling Stone* magazine in San Francisco.

Marshall McLuhan and Quentin Fiore's *The Medium Is the Massage* is published.

Aretha Franklin, the Doors, Janis Joplin, and Jimi Hendrix top the charts.

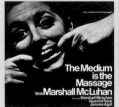

January: *Rowan & Martin's Laugh-in* premieres on TV.

January 31: The Tet Offensive is launched by the Viet Cong.

March 31: With Vietnam policies becoming increasingly unpopular, President Johnson makes a surprise announcement that he will not run for reelection.

April: Title VIII of the Civil Rights Act of 1968 (the Fair Housing Act) prohibits racial discrimination in housing.

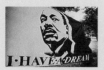

April 4: Martin Luther King Jr. is shot and killed in Memphis by James Earl Ray.

May 12–June 19: Poor People's March on Washington takes place.

April: The number of U.S. troops in Vietnam reaches 543,000.

May 15–30: People's Park riots take place in Berkeley.

June 27: The Stonewall riots in New York mark the rise of the gay liberation movement.

July 21: Neil Armstrong walks on the moon.

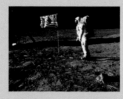

August 9: Members of the "Manson family" murder Sharon Tate and four friends in Los Angeles.

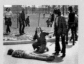

May 4: Members of the National Guard fire on antiwar demonstrators at Kent State University in Ohio, leaving four students dead and eight wounded.

The Native American Rights Fund is founded to protect the rights of Native Americans and push for legislation protecting the sovereignty of tribal lands.

Patton, starring George C. Scott as a military "rebel," wins the Oscar for best picture.

19**68** 19**69** 19**70**

June 6: Robert F. Kennedy is shot and killed by Sirhan Sirhan in Los Angeles while campaigning for the Democratic presidential nomination.

August 26–28: Antiwar demonstrators clash with police at the Democratic National Convention in Chicago.

October: American medalists Tommy Smith and John Carlos are expelled from the Mexico City Olympics after giving the black-power salute during the award ceremony.

November: Richard M. Nixon is narrowly elected over Hubert Humphrey as the 37th president.

Tom Wolfe's *The Electric Kool-Aid Acid Test,* a tale of Ken Kesey's Merry Pranksters, is published.

August 15–17: The Woodstock Music and Art Fair gathers 450,000 people in Bethel, New York, for three days of "peace and music."

October 15: Nationwide Moratorium Day protesting the Vietnam War. More than 250,000 people gather in Washington, D.C.

November: The group Indians of All Tribes begins a 19-month occupation of Alcatraz Island off San Francisco to raise awareness about U.S. policies that coerced Native Americans to dissolve tribes and assimilate in cities. Subsequently, such government policies were terminated in favor of Native American self-determination, and in 1970, Blue Lake and 48,000 acres of land in New Mexico were returned to the Taos Pueblo.

Public Broadcasting Service (PBS) begins broadcasting.

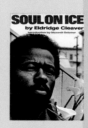

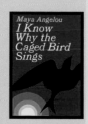
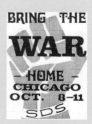

63

Larry Bell
B. 1939, CHICAGO; LIVES AND WORKS IN TAOS, NEW MEXICO

Raised in Los Angeles, Bell attended the Chouinard School of Art in Los Angeles from 1957 to 1959. Though not particularly stimulated by his academic experience, he realized the potential for glass as an art medium while working in a frame shop. He experimented with glass scraps and was fascinated by the way glass reflects and transmits light. His early works consisted of shadow boxes and constructions of glass and backing papers used in framing. He would fill the boxes with scraps of cracked glass, which cast interesting shadows on the paper. Bell's sculptures known as Cubes came about when he was looking around his studio and realized that right angles are everywhere and in fact make up the bulk of our spatial experience. Wanting to find something new to say about this geometric reality, Bell used commercial plating processes to make tinted and reflective glass cubes that transform the light that passes through them. His Minimalist approach to processes, forms, and materials has remained consistent throughout his career, and he has been recognized by artists of the Los Angeles school of "light and space" for his construction of elegant, geometric glass sculptures and installations.

Larry Bell
Untitled
1965
Glass
8½ × 8½ × 8½ in.
Collection of Robert and Shaké Sarkis
© Larry Bell

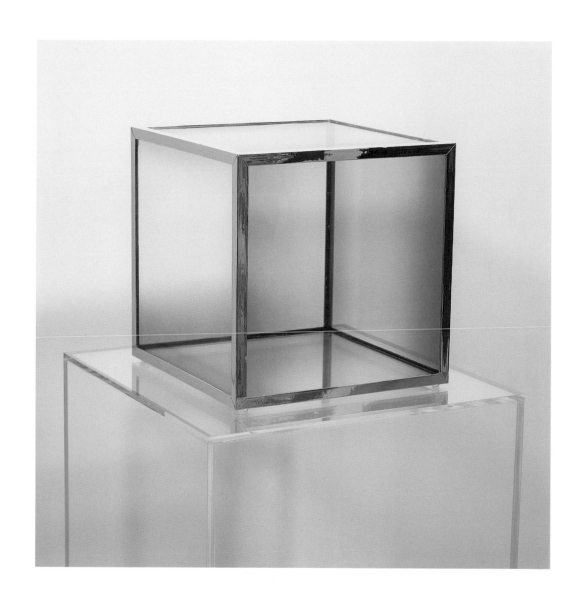

Willem de Kooning
B. 1904, NETHERLANDS; D. 1997, EAST HAMPTON, NEW YORK

De Kooning was raised in Rotterdam and received most of his early art education as an apprentice at a commercial art firm. Later he worked as a sign painter and studied painting at night in classes at the Rotterdam Academy of Fine Arts and Techniques. He was influenced by the geometric designs of the Dutch de Stijl (the Style) movement and its founder, Piet Mondrian. De Kooning's interest in modern art was also piqued by his encounters with Cubist paintings while visiting museums in Belgium, where he lived in 1924–26 to continue his studies. He went to America in 1926, residing first in Hoboken, New Jersey, before settling in New York City in 1927. He supported himself for a few years working as a house painter. He met many of the avant-garde artists in New York, including Stuart Davis, Arshile Gorky, and John Graham, and in a departure from the clean geometric compositions of his earlier art, he began to use experimental techniques and processes. He became close friends with Gorky, who shared his admiration for Miró, Picasso, and the Cubists and had a strong influence on de Kooning's work. Gorky's suicide in 1948 left de Kooning devastated. His emotional outpouring over the loss of his friend manifested itself in dark, violently rendered paintings. This evolved into an obsession with the human figure, and in 1952 had matured into what came to be known as his *Women* series. In these loosely rendered paintings, de Kooning explored the image of women as sex symbols, mothers, and treacherous vampires, among other depictions. He would alternate between his *Women* series and pure abstraction throughout the remainder of his career.

Willem de Kooning
Woman with Smile
1967
Oil on canvas
23½ × 18½ in.
Collection of Jane and David Davis
© The Willem de Kooning Foundation / Artists Rights Society (ARS), New York

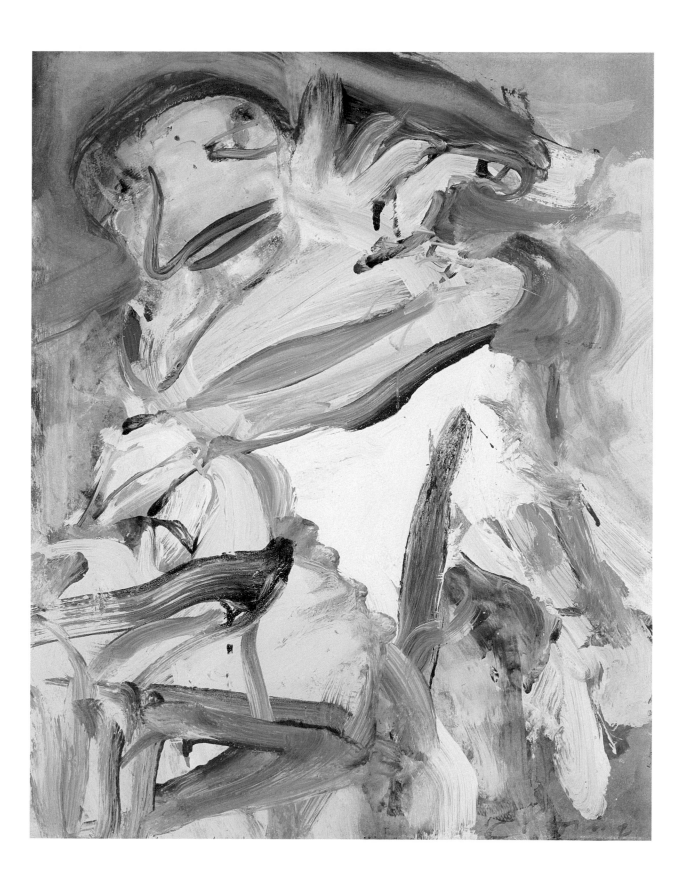

Helen Frankenthaler
B. 1928, NEW YORK; LIVES AND WORKS IN NEW YORK

Frankenthaler studied at a number of art schools, including Hans Hofmann's School of Fine Art in New York. By 1950 she had met many of the main figures of Abstract Expressionism, and from 1958 to 1971 she was married to Robert Motherwell. Inspired by watching Jackson Pollock drip his paint, Frankenthaler modified the process by carefully pouring thinned pigment onto unprepared canvas. Her first major painting in this manner, *Mountains and Sea* of 1952, is considered by many, including the critic Clement Greenberg, to be the first monument of Post-Painterly Abstraction (or Color Field painting) and remains one of the most important works in that style. The painters Morris Louis and Kenneth Nolan were deeply impressed after visiting her studio in 1953 and began to experiment with the techniques she was employing. In 1962, she abandoned oil in favor of acrylic paint, which allowed her to create stronger colors and greater vibrancy. She experimented with many other media, including ceramics, sculpture, and printmaking. Throughout her career, Frankenthaler has maintained the early elements of her style. The "soak stain" technique she made famous is still an integral part of her work. Although her paintings are generally considered abstractions, they contain a strong suggestion of landscape.

Helen Frankenthaler
Dawn Shapes
1967
Acrylic on canvas
77 × 93¾ in.
Collection of Jane and David Davis
© Helen Frankenthaler

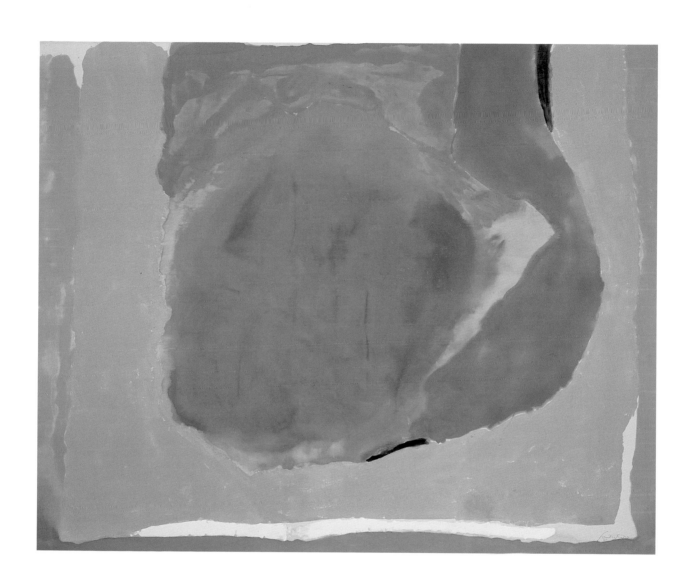

Eva Hesse
B. 1936, HAMBURG, GERMANY; D. 1970, NEW YORK

Hesse's family moved to New York City in 1939 to escape World War II. She became a U.S. citizen in 1945. Her parents divorced that same year, and her mother committed suicide a year later—events that would deeply affect the artist. Hesse attended Pratt Institute in Brooklyn in 1952, studied at Cooper Union from 1954 to 1957, and then won a scholarship to attend Yale University, where she studied painting with Josef Albers, receiving her BFA in 1959. In 1961, she married sculptor Tom Doyle. The 1960s saw her working on her first three-dimensional objects and participating in Happenings with Allan Kaprow and Walter De Maria. In 1964, she traveled throughout Europe thanks to the patronage of a wealthy German textile manufacturer. Also around this time, she began to work with latex and fiberglass—the materials for which she is best known. Her art is often associated with the Minimalist movement because of its use of simple, repeated forms, but she embraced fragile and flexible materials, such as latex and rubber-covered cheesecloth, that lent her work a fugitive quality. As a result, many of her sculptures defy conservation. She taught at the School of Visual Arts in New York from 1968 to 1970, when her career was cut tragically short by her death of a brain tumor.

Eva Hesse
Stratum
1967–68
Latex with white pigment, string, and grommets
42 × 42 in.
Collection of the Museum of Art / Washington State
University, Pullman
© The Estate of Eva Hesse. Courtesy of Hauser &
Wirth, Zurich and London

Andy Warhol
B. 1928, PITTSBURGH; D. 1987, NEW YORK

Warhol received his BFA from the Carnegie Institute of Technology, Pittsburgh, in 1949. He moved to New York that same year and became successful as a commercial artist and illustrator, recognized especially for his illustrations of I. Miller shoes. His drawings were published in glamour magazines and displayed in department store windows. In 1956, he traveled throughout Europe and Asia. In the early 1960s, he began to paint repetitious and banal subject matter such as Coca-Cola bottles, soup cans, celebrity head shots, and comic strips, helping to launch the Pop movement. By 1963, he had abandoned painting for the silkscreen process, leading to his being criticized by some for exploiting assistants to make his work, which included his series of disasters, flowers, cows, and portraits, as well as three-dimensional facsimiles of well-known household products such as Brillo boxes. In the mid-1960s, Warhol opened the Factory, his New York studio that became a locus of the art, fashion, and subculture scenes. There he concentrated on making repetitious and voyeuristic films that emphasized boredom. In 1968, he was shot and wounded by a minor actress in one of his films, an event that only cemented his larger-than-life persona (ironically, he would die from complications following routine gallbladder surgery in 1987). In the early 1970s, he began to paint again, returning to loose gestural brushwork, and produced monumental portraits of Mao Tse-tung, commissioned portraits of wealthy patrons, and the *Hammer and Sickle* series. He and his Factory published *Interview* magazine, and he released numerous books, including *The Philosophy of Andy Warhol (From A to B and Back Again)* (1975).

Andy Warhol
Campbell's Soup Cans
1968
Silkscreen
35 × 23 in. each (4 images)
Collection of Richard Weisman
© 2006 Andy Warhol Foundation for the Visual Arts /
Artists Rights Society (ARS), New York / TM Licensed
by Campbell's Soup Co. All rights reserved.

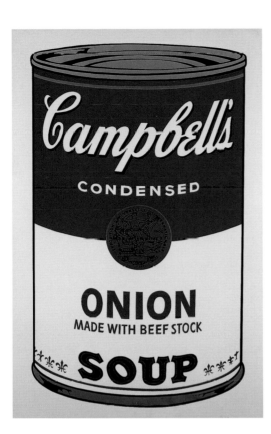

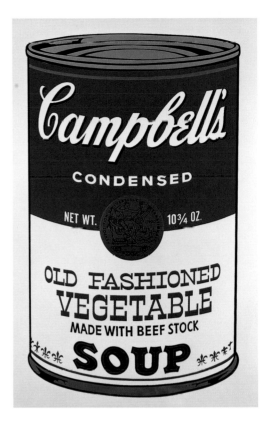

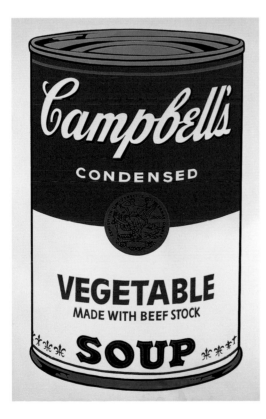

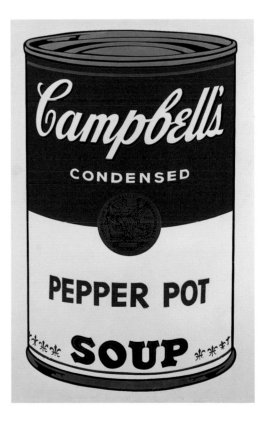

Donald Judd
B. 1928, EXCELSIOR SPRINGS, MISSOURI; D. 1994, NEW YORK

Judd was a sculptor, painter, and influential writer closely tied to the Minimalist movement. His academic training was extensive, including art theory as well as painting and sculpture. He studied at the Art Students League (1947–48, 1950–53), attended the College of William and Mary in 1948, graduated with a degree in philosophy from Columbia University in 1953, and received his MA in art history from Columbia in 1962, studying under renowned art historian Meyer Schapiro. Judd's first works were untitled paintings in which he sought to simplify composition and to eliminate the balancing of forms. He wished to avoid elements that he felt characterized postwar European art, such as personal expression and spatial illusion. He wrote art criticism for *Arts*

Magazine from 1959 to 1965, advocating the work of artists such as Claes Oldenburg, Frank Stella, John Chamberlain, and Dan Flavin. In the early 1960s, Judd abandoned painting and devoted himself to sculpture. In his 1964 essay "Specific Objects," he indicated that by using a three-dimensional object in "real space," he could avoid the temptation of creating illusional space. The geometric simplicity of his abstract painted structures, first in wood and then in industrially manufactured metals, constituted a three-dimensional counterpart to Color Field painting. By placing the objects directly on the ground rather than on a plinth or base, Judd further emphasized their self-sufficiency as objects in space.

Donald Judd
Untitled
1969
Clear anodized aluminum and plexiglass
33 × 68 × 48 in.
Collection of Virginia and Bagley Wright
Art © Judd Foundation / Licensed by VAGA, New York

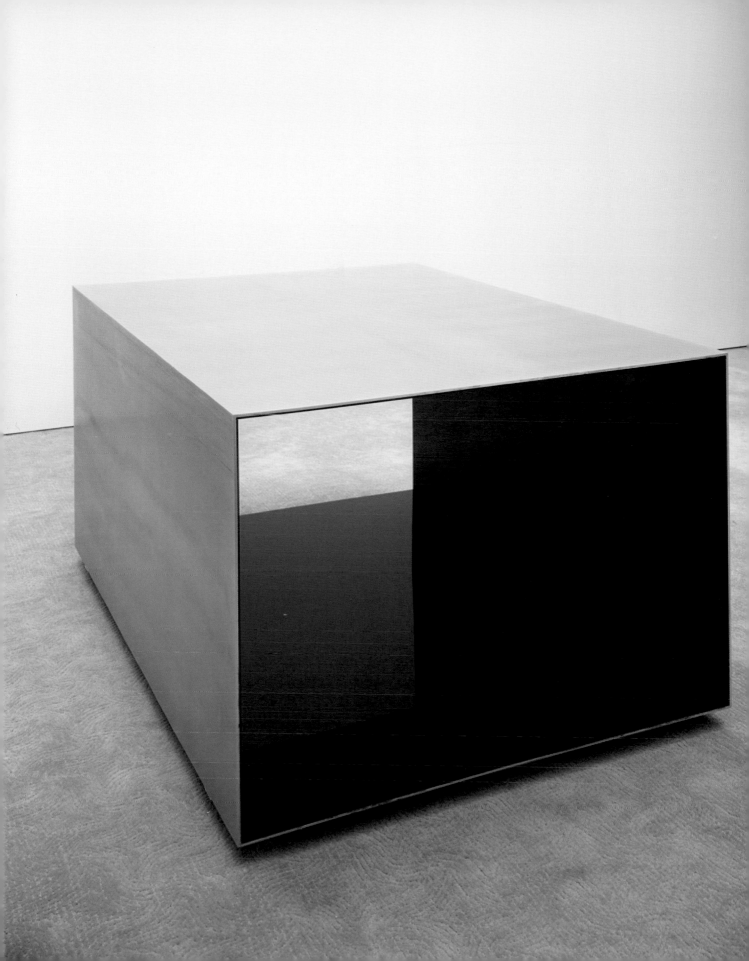

Claes Oldenburg
B. 1929, STOCKHOLM, SWEDEN; LIVES AND WORKS IN NEW YORK

Oldenburg's father was a Swedish diplomat, and after residing in New York City and Norway, the family settled in Chicago in 1936. Oldenburg studied literature and art history at Yale University from 1946 to 1950 and at the Art Institute of Chicago from 1950 to 1954. He also worked, for a short period, as a reporter at the City News Bureau of Chicago. In 1956, he moved to New York, where he met several performance artists, including George Brecht, Allan Kaprow, George Segal, and Robert Whitman. Oldenburg was soon immersed in Happenings and performance art during the late 1950s and early 1960s. His work by 1959 included grotesque human figures and everyday objects made from drawings, collages, and papier-mâché. In 1961, he opened *The Store* in his studio, where he re-created the environment of neighborhood shops to display familiar objects made out of plaster. He had constructed a commentary on America's celebration of consumer culture while simultaneously exploiting it to sell his own sculpture. He soon emerged as a leading Pop artist, creating oversized soft sculptures of everyday objects made from hand-sewn fabrics. Beginning in the mid-1960s, he began making colossal public art projects. The first of these works, *Lipstick (Ascending) on Caterpillar Tracks*, was installed at Yale University in 1969. Oldenburg married artist and writer Coosje van Bruggen in 1977, and she has collaborated with him on most of his large-scale projects. In the mid-1970s and again in the 1990s, Oldenburg and van Bruggen collaborated with the architect Frank O. Gehry, breaking the boundaries between architecture and sculpture. In 1991, as part of Gehry's Chiat/Day building in Los Angeles, Oldenburg and van Bruggen created a binocular-shaped sculpture-building. Over the past few decades, Oldenburg has remained active and his works have been the subject of many performances and exhibitions.

Claes Oldenburg
Sculpture in the Form of a Trowel Stuck in the Ground—Model
1969–70
Wood painted with lacquer
44 × 29⅝ × 24¼ in.
Collection of Richard Weisman
© Claes Oldenburg

Carl Andre

B. 1935, Quincy, Massachusetts; lives and works in New York

Andre studied art under Patrick Morgan at the Phillips Academy in Andover, Massachusetts (1951–53), then enrolled at Kenyon College, Ohio, but left in 1954 to travel to England and France. He joined the U.S. Army and worked in military intelligence in North Carolina in 1955. In 1957, he moved to New York and worked for a publishing house. He began creating wood sculptures influenced by Constantin Brancusi and by the black paintings of his friend Frank Stella. Andre was an important figure of the Minimalist movement during the early to mid-1960s. Working within a strict, self-imposed modular system, he used commercially available materials or objects, usually identical in measurement, such as timber, styrofoam, cement blocks, and bales of hay.

His work is often referred to as "Taoist" or "Pacific" because of its simplicity and strong sense of order. In addition to making sculpture, he also wrote poetry. While maintaining a career as an artist, he worked as a conductor for the Pennsylvania Railroad in New Jersey from 1960 to 1964. In the 1970s, he created several large-scale installations, such as *Equivalent VIII* at the Tate Gallery in London. The response to the museum's purchase of this installation was mixed, and few saw the irony in his creation of a cubic construction made of bricks for a gallery named after a man who had made his fortune manufacturing sugar cubes. In his current work Andre continues to emphasize placement, environment, and materials in relation to specific uses of space.

Carl Andre
Plain (Magnesium and Copper)
1970
Magnesium and copper
12 × 12 × ⅜ in. each, 72 × 72 × ⅜ in. overall
Collection of Virginia and Bagley Wright
Art © Carl Andre / Licensed by VAGA, New York